SOUNDING
THE DEPTHS

SOUNDING THE DEPTHS

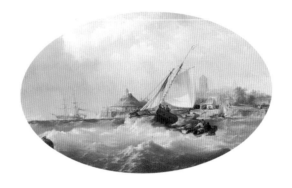

150 YEARS OF AMERICAN SEASCAPE

HAROLD B. NELSON

The American Federation of Arts

Chronicle Books
San Francisco

This catalogue has been published in conjunction with *Sounding the Depths: 150 Years of American Seascape*, an exhibition organized by the American Federation of Arts. The exhibition and publication have been made possible through the generous support of the National Endowment for the Arts. The exhibition has been additionally supported by the Lila Wallace-Reader's Digest Fund through their generous contribution to the AFA's pilot project ART ACCESS. The catalogue has been additionally supported by the J. M. Kaplan Fund, the DeWitt Wallace Fund, and the Henry Luce Foundation through the AFA's Revolving Fund for Publications.

The American Federation of Arts is the nation's oldest and largest non-profit organization serving the visual arts community. Its primary activity is the organization of exhibitions and film programs that travel throughout the United States and abroad. Other services to museums include a fine-arts insurance program, technology services, design awards to the field, workshops and institutes for museum professionals, and discount services.

Printed in Hong Kong
AFA Exhibition No. 136

Produced by Ed Marquand Book Design, Seattle
Composition by Continental Typographics, Los Angeles

"The Bathers" (excerpt) from *The Complete Poems and Selected Letters and Prose of Hart Crane*, edited by Brom Weber, copyright ©1933, 1958, 1966 by Liveright Publishing Corporation. Reprinted by permission of Liveright Publishing Corporation.

"Passage Over Water" (excerpt) from *The Opening of the Field* by Robert Duncan, copyright ©1960 by Robert Duncan. Reprinted by permission of New Directions Publishing Corporation.

"Once by the Pacific" from *The Poetry of Robert Frost*, edited by Edward Connery Lathem, copyright ©1928 by Holt, Rinehart and Winston and renewed 1956 by Robert Frost. Reprinted by permission of Henry Holt and Company, Inc.

"Fishermen's Last Supper" from *The Collected Poems of Marsden Hartley: 1904–1943*, copyright ©1987 by Yale University by permission from the heirs of Marsden Hartley. Reprinted by permission of Black Sparrow Press.

"Odysseus" from *The First Four Books of Poems*, copyright ©1956, 1957, 1958, 1959, 1960 by W. S. Merwin. Reprinted by permission of Atheneum Publishers, an imprint of MacMillan Publishing Company.

"To the Harbormaster" from *Meditations in an Emergency*, copyright ©1957 by Frank O'Hara. Reprinted by permission of Grove Press, a division of Wheatland Corporation.

CATALOGING-IN-PUBLICATION DATA

Nelson, Harold B., 1947–
 Sounding the depths.

(AFA exhibition; no. 136)
Catalogue of an exhibition held at Milwaukee Art Museum
 and others, June 15, 1989–Apr. 21, 1991.
Bibliography: p.
Includes index.
1. Sea in art—Exhibitions. 2. Art, American—Exhibitions. I. American Federation of Arts. II. Milwaukee Art Museum. III. Title. IV. Series.
N8240.N45 1989 758'.2'0973074013 89-551
ISBN 0-87701-598-8

Contents

Acknowledgments

For *Sounding the Depths: 150 Years of American Seascape*, Harold B. Nelson, formerly the American Federation of Arts' acting director of exhibitions, has selected an outstanding group of works of art that survey this important genre, and has written a rich commentary about them. Special thanks go to him for his tenacity in curating this exhibition with sensitivity and energy while also handling his varied and extensive duties.

A number of other individuals at the AFA have contributed their time and creative energy to make this exhibition a reality. I would like to thank Robert M. Murdock, former director of exhibitions, for his overall guidance; Michaelyn Mitchell, publications coordinator, for shepherding the publication; and Sandra Gilbert, public information and promotion director, for arranging the publicity for the national tour.

The AFA is particularly grateful for the extraordinary generosity of the trustees and staff of the Butler Institute of American Art in Youngstown, Ohio. Without their substantial loan and the support of Dr. Louis Zona, the Institute's director, this exhibition and book would not have been possible.

We also want to acknowledge the numerous other institutions and individuals who have so generously loaned their works: the Mead Art Museum, Amherst College; the Bostonian Society, Old State House, Boston; the Columbus Museum of Art; the Montclair Art Museum; the Metropolitan Museum of Art; the University Art Museum, University of Minnesota; the Eli Broad Family Foundation; the Herbert W. Plimpton Collection, on extended loan to the Rose Art Museum, Brandeis University; Michelle Stuart, courtesy of Max Protetch Gallery; Joe Zucker, courtesy of Hirschl and Adler Modern; Luis Cruz Azaceta, courtesy of Frumkin/Adams Gallery; Jody Pinto, courtesy of Hal Bromm Gallery; the Rothschild Bank AG, Zurich; the La Jolla Museum of Contemporary Art; Brooke and Carolyn Alexander; the Brooke Alexander Gallery; Michael McMillen, courtesy of Patricia Hamilton Gallery; Mr. and Mrs. Frederick R. Mayer; Wade Saunders, courtesy of Diane Brown Gallery; and the Emily and Jerry Spiegel Collection.

We wish to thank as well the museums that will be presenting *Sounding the Depths* in their galleries: the Milwaukee Art Museum; the Art Museum of South Texas, Corpus Christi; the Orlando Museum of Art; the Museum of Art, Science, and Industry, Inc., Bridgeport; the Butler Institute of American Art, Youngstown; and the Honolulu Academy of Arts.

Finally, we wish to express our appreciation to the National Endowment for the Arts for its generous grant to both the exhibition and publication; to the Lila Wallace-Reader's Digest Fund for its contribution to the AFA's pilot project ART ACCESS; and to the J. M. Kaplan Fund, the DeWitt Wallace Fund, and the Henry Luce Foundation for their support of the project through the AFA's Revolving Fund for Publications.

Myrna Smoot
Director
The American Federation of Arts

Preface

Sounding the depths—taking the measure, gauging the distance between sea-going vessel and ocean floor. A sounding is a linear measurement that answers the question of ultimate importance to the seafarer—what degree of danger does the sea pose to the well-being of the ship? Is it safe to pass through shallow waters? Must an alternate course be sought? Soundings are a simple means of physical measurement. Soundings may also be perceived more expansively as metaphorical readings of man's ever-changing relationship to the vast unknowable expanse of the sea, to the immeasurable mysteries of nature, or to the elusive recesses of the psyche.

Over the past 150 years, an extraordinarily diverse range of American artists have explored the rich visual imagery of the sea. Although their styles differ radically, their similar interest in the subject links them. *Sounding the Depths: 150 Years of American Seascape* includes paintings, watercolors, and sculptures that present seascape both as a physical fact—a record of an actual place or event—and as a multifaceted visual metaphor. The selection draws largely on the rich collection of American art at the Butler Institute of American Art in Youngstown, Ohio, where founding director Joseph Butler was particularly interested in the seascape genre. The strengths of this selection, especially in the nineteenth- and early twentieth-century areas, parallel the great strengths of that collection.

The places depicted in these works are ever-varying, from the rocky headwalls of the Cornish coast to the peaceful salt marshes around Newburyport, Massachusetts. The metaphors most frequently concern man's changing relationship to the uncontrollable forces of nature and his efforts to control, order, contend with, or otherwise make sense of this chaos. Seascape has been used variously to signify the abundance and harmony of the universe, the fear of the annihilation of mankind by nature's rash and destructive forces, man's dread of the potential loss of nature's ecological balance through human greed and wastefulness, and the desire to abandon the will, even the self, to a sea of egolessness. Ultimately, the metaphor involves mankind's desire, or compelling need, for order and control in the face of a seemingly chaotic universe.

Harold B. Nelson
Director
Long Beach Museum of Art

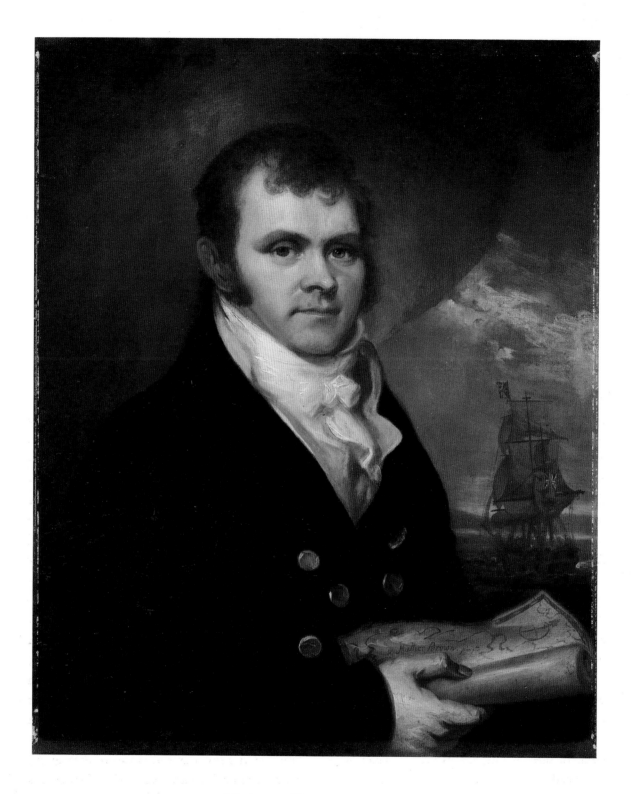

MATHER BROWN (1761–1831)

Portrait of an Unknown Gentleman, c. 1820

Oil on canvas, 30 × 25 in.

Mead Art Museum, Amherst College,

Amherst, Massachusetts

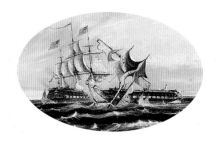

Man as Master of the Sea

My Brigantine!
Trust to the mystic power that points thy way,
Trust to the eye that pierces from afar,
Trust the red meteors that around thee play,
And, fearless, trust the Sea-Green Lady's Star,
Thou bark divine!

—from *My Brigantine*
James Fenimore Cooper

Among the earliest images of seascape produced in this country are portraits of prosperous colonial merchants, sea captains, and naval officers painted by American artists from the late seventeenth into the early nineteenth centuries. Most of the major artists active in the New England and mid-Atlantic colonies during this period—from Joseph Badger, Robert Feke, and John Smibert to John Singleton Copley, John Greenwood, Ralph Earl, and Charles Willson Peale—were commissioned to paint such portraits. The intent, in addition to capturing their likenesses, was to assert the social, economic, or political status of these notable individuals.

Radiating pride, confidence, and satisfaction with his own achievement, the subject of such a portrait is most often situated in an interior space in front of a window that opens onto a marine vista. In these works, the earliest of which were produced according to visual formulas derived from seventeenth- and eighteenth-century British mezzotints and engravings, the focus of attention is always on the human figure; the harbor, ship, or seascape are included merely to provide information about the individual and the source of his prosperity or status. Almost without exception,

the human figure visually and psychologically dominates the space surrounding it. Posing no threat to the stability or well-being of the sitter, the sea is a tranquil body whose forces have been completely subjugated to the will of man. In this space, man's navigational abilities lend structure to the world about him and bring order to the potential chaos of the sea. In these portraits, man's mastery of the sea, his domination of nature, defines his status on earth.

In the very earliest of these portraits, worldly status was rarely perceived to be of paramount importance. Indeed, in the seventeenth century, the seascape served a metaphorical role in addition to an informational one. In Captain Thomas Smith's *Self-Portrait* (fig. 1) of c. 1690, the subject is dressed in sober attire and is situated in a tenebrous interior environment. However, through the window, beyond the dark tranquility of the sitter's space, a furious sea battle rages. Although the inclusion of the human skull, a traditional memento mori, serves as the clearest symbolic statement of the vanity of all worldly pursuit, the contrasts of light and dark, exterior and interior, sea space and human space, resonate with and deepen

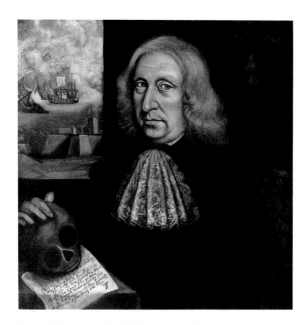

Fig. 1 Thomas Smith, *Self-Portrait*, c. 1690, oil on canvas, 24½ × 23¾ in., Worcester Art Museum, Worcester, Massachusetts.

this meaning. The message is even more clearly articulated in the painting's inscription:

Why why should I the World be minding
therin a World of Evils Finding.
Then Farwell World: Farwell thy Jarres
thy Joies thy Toies thy Wiles thy Warrs
Truth Sounds Retreat: I am not sorye.
The Eternall Drawes to him my heart
By Faith (which can thy Force Subvert)
To Crowne me (after Grace) with Glory.

In this portrait Smith presents the pursuit of the spiritual realm as man's primary mission and suggests that victory in battle and joy in life are merely temporal rewards. The artist uses the sea battle as a visual metaphor suggesting the vanity of all human conquest, the futility of worldly gain. By the mid-eighteenth century, however, the use of the sea journey as a metaphor for the spiritual quest had virtually disappeared, as the religious focus of the seventeenth century gave way to the pragmatic, confident humanism of the eighteenth.

In James Fenimore Cooper's ebullient ode to a sailing vessel (see epigraph), which fairly bursts with poetic swellings, neither gentle breeze nor howling tempest can stir this ship from its course. Optimism, trust, and faith, Cooper suggests, will guide the vessel to the end of its journey, will guide man through his life. This unfailing belief in mankind's ability to master the elemental forces of the universe as symbolized by the sea is typical of the optimism of the late eighteenth and early nineteenth centuries.

Mather Brown's *Portrait of an Unknown Gentleman* of c. 1820 (p. 8) depicts a man elegantly but soberly attired in the uniform of the merchant marine. The nautical map held firmly in his right hand, his confident gaze, and the ship bearing the Union Jack in the distance all connote the sitter's profession and secure mastery of his craft.

Brown's simple massing of forms and painterly handling of pigment underscore his indebtedness to his contemporary Gilbert Stuart, with whom he studied prior to 1780. In *Portrait of an Unknown Gentleman*, the sitter's conventional three-quarter pose also serves as a transition to safe, inhabited interior space from sea space, where man is more vulnerable. The exterior scene, however, poses no threat to the tranquility of the sitter's world. In fact, the sea space Brown describes is a secure harbor with land masses beyond. Thus land and sea are joined, and man is master of both realms. Falling squarely within eighteenth-century portrait conventions, the figure commands the space around it: within this space, man is clearly master of his world, master of the sea.

The theme of man's mastery of the sea, his domination of the social and political as well as natural forces surrounding him, has a second dimension which can be seen in paintings depicting sea battles. While the battle in Captain Thomas Smith's *Self-Portrait* may depict an actual event, its

significance lies primarily in its suggestion of the vanity of worldly gain. Very different in intent, Thomas Chambers's *Capture of the Guerrière by the Constitution* (p. 15) is first and foremost a descriptive record of a naval battle that took place during the War of 1812. Under the command of Captain Isaac Hull, the *Constitution* intercepted H.M.S. *Guerrière* in August of 1812, and in a battle lasting only half an hour managed to completely dismast the British ship and emerge victorious. It was during this battle that the U.S. ship won the nickname *Old Ironsides*.

Even more important than its documentation of an actual naval victory is the symbol this work presented of America's pride in its new nationhood and in its ability to fend off all foes. Chambers received numerous commissions to repeat this image, which originally derived from a painting by Thomas Birch entitled *The Constitution and the Guerrière* (c. 1845), now in the collection of the Metropolitan Museum of Art, New York. The popularity of Chambers's painting suggests that the subject and the patriotism it embodied struck a deep chord in the American spirit. *Capture of the Guerrière by the Constitution* was among the first works to equate ship and nation/state, an equation that came to be employed frequently by artists and poets throughout the nineteenth and into the twentieth centuries.

In his well-known *The Building of the Ship*, Henry Wadsworth Longfellow also used the analogy of ship and state to speak of the Union as the work of many hands:

We know what Master laid thy keel,
What Workmen wrought thy ribs of steel,
Who made each mast, and sail, and rope,
What anvils rang, what hammers beat,
In what a forge and what a heat
Were shaped the anchors of thy hope!
Fear not each sudden sound and shock,

'Tis of the wave and not the rock;
'Tis but the flapping of the sail,
And not a rent made by the gale!
In spite of rock and tempest's roar,
In spite of false lights on the shore,
Sail on, nor fear to breast the sea!

Perhaps the ultimate expression of this metaphor occurs in Walt Whitman's *O Captain! My Captain!* of 1865. The captain to whom Whitman referred is Abraham Lincoln, and the journey is America's passage through the strife of the Civil War. In this painfully double-edged work, Whitman celebrated the Union victory and the reunification of the country and lamented the loss of Lincoln, the master of the victorious ship. The pride and self-assurance apparent in earlier nineteenth-century poetry and paintings in this poem give way to despair and confusion. Similarly, as seascape imagery evolved throughout the late nineteenth century into the twentieth, the pessimistic strain apparent in Whitman's work became more commonplace. Gradually, nineteenth-century artists and poets began to see man no longer as master of all the forces surrounding him, but as a finite presence subject to abstract elements often more powerful than himself.

Early in the nineteenth century a tradition of ship portraiture emerged in this country and endured even into the early years of the twentieth century. Artists were commissioned by owners of sailing vessels to produce detailed likenesses of the ships in whose ownership they took great pride. In such a portrait the ship is almost always presented in a broadside view, enabling the artist to include the maximum amount of visual information about it—the nature of the rigging, the size of the crew, the number and types of sails. A low horizon line allows the ship to fully command and define the space surrounding it, and the generally calm waters upon which it sails pose little apparent threat to its well-being. As is the case of portraits of sea cap-

tains, ship portraits exude an air of confidence, power, and mastery of the forces of nature.

In *Ship Huntress* of 1855 (p. 16), the earliest of the ship portraits included in this selection, William Smith Jewett presented a three-masted vessel sailing under the American flag and nearing land in the company of several other ships. The size, proximity, detailing of rigging and masts, and broadside presentation confirm that *Ship Huntress* is indeed a ship portrait rather than a generalized marine view. Working in San Francisco during the gold rush, Jewett developed a considerable reputation there as a painter of landscapes, portraits, and ship portraits.

James E. Buttersworth is considered among the foremost ship portraitists of the nineteenth century. He exhibited his work frequently throughout the 1850s at the American Art Union in New York. Many of the detailed harbor scenes and ship portraits in which he specialized served as prototypes for lithographs executed by the firm of Currier and Ives between 1847 and 1865. *Ship Valparaiso* (p. 17), in its exact detailing of the vessel's sails and rigging, is typical of the artist's ship portraits; however, the ships in the background circling in the harbor and the visual prominence of the sunset lend this work a buoyancy and quiet poetry unusual for Buttersworth's work in this genre.

In Jewett's *Ship Huntress* and Buttersworth's *Ship Valparaiso*, the sturdy bark and the sleek clipper are presented in close proximity to land, suggesting the beginning or the end of a sea journey. In *Navahoe, Clyde Steamship Company* of 1898 (p. 18) and *Steamer Kroonland (Red Star Line)* of 1903 (p. 19), Antonio Jacobsen presented vessels in the open sea and in complete command of the waters surrounding them. Considered the foremost American ship portraitist of the last quarter of the nineteenth century, Jacobsen was frequently commissioned to paint detailed likenesses

of commercial ships by shipping companies or by the captains of these vessels. *Navahoe, Clyde Steamship Company*, a portrait of a 1,637-ton steamship built in Hamburg, Germany, in 1880 for the Clyde Line of New York, is one of five portraits Jacobsen painted of the *Navahoe* between 1897 and 1909. In the work the proportions of the single-stack steamship are very slightly attenuated to lend the vessel a greater sleekness. Even the broad linear handling of the waves serves to accentuate the smooth-flowing motion of the ship.

By contrast, the solid weight and bulk of the double-stacked steamship in *Steamer Kroonland (Red Star Line)* lend the painting its force. Typical of Jacobsen's late work, the rendering of the vessel is sharp and precise. But the seas are choppier and handled in a more painterly manner than is customary for Jacobsen. The *Kroonland* was built in 1902 by William Cramp and Sons in Philadelphia, and this fine portrait of it is one of three known to have been painted by Jacobsen between 1903 and 1905.

Although the tradition of ship portraiture continued well into the twentieth century in the work of Jacobsen, Frederick Schiller Cozzens, Montague Dawson, Henry Scott, and others, a sense of nostalgia characterizes the late work in this genre. The passing of the age of the great clipper ships, the age of sail, is clearly apparent in James Hamilton's *From Sail to Steam* (p. 20). Known as the "American Turner" because of his highly dramatic ship portraits, naval battles, and other marine views, Hamilton's numerous visual presentations were much more than mere likenesses of particular vessels, events, or locales. In *From Sail to Steam* a single-stack steamer dominates the harbor as vessels propelled by sails alone recede in the distance. The brilliant colors of the setting sun beautifully underscore the nostalgia inherent in the subject. As man replaced sailing vessels with

steam-powered ships, his central relationship to nature was transformed. No longer reliant on the whims and vicissitudes of the wind and water, man's industry now powered his craft. Hamilton's *From Sail to Steam*, while celebrating man's invention, also laments the loss of that intimate relationship to nature.

Walt Whitman articulated an even more clearly pronounced remorse at the demise of a great sailing vessel in *The Dismantled Ship*:

In some unused lagoon, some nameless bay,
On sluggish, lonesome waters, anchor'd near
 the shore,
An old, dismasted, gray and batter'd ship,
 disabled, done,
After free voyages to all the seas of earth, haul'd up
 at last and hawser'd tight,
Lies rusting, mouldering.

His lament is all the more poignant in its metaphorical implications; the poet seems to suggest that individual human lives often end in such circumstances.

A spiritual rather than elegiac quality characterizes Fitz Hugh Lane's ship portrait, *Ship Starlight in the Fog* of 1860 (p. 21). *Starlight* was a medium-sized clipper ship built by E. and H. O. Briggs in South Boston in 1854 for Baker and Merrill of Boston. As were the majority of clipper ships, *Starlight* was used most frequently for passages from New England to San Francisco. She was reported to be of moderate speed, making her swiftest passage between Boston and San Francisco in 117 days. In 1864 the ship was sold to a new owner in Lima, Peru, and was used from then on to transport Chinese laborers. The ship was last recorded in San Francisco in 1865.

Lane took up marine subjects in the late 1830s, influenced by the work of Robert Salmon, a British-trained painter of ship portraits and harbor views. Lane's signature work of the 1850s and 1860s is characterized by its clarity of composition, balance, and underlying geometric order, and by the presence of a sublime, pervasive light. Along with Martin Johnson Heade and John F. Kensett, Lane is considered one of the major figures of the American Luminist movement.

Although adhering to the principal conventions of nineteenth-century ship portraiture in its portside view and its inclusion of copious detail, *Ship Starlight in the Fog* departs significantly from standard formulas. Prosaic in intent, the goal of the ship portrait was to capture the exact likeness of a vessel and thus to memorialize it as well as its owner and its maker. While Lane indeed captured the ship's likeness, the striking work is much more than a visual record of a particular ship.

Ship Starlight in the Fog can also be seen as a treatise on the relationship of the individual to the eternal. In the foreground Lane has placed a solitary human figure in a boat just off the axis formed by the reflection of the sunlight upon the water. The vibrant red of the figure's shirt draws attention to the individual, seen against a backdrop of pervasive light that seems to almost emanate from within the canvas. Although no land massings suggest the safe moorings of a harbor, the *Starlight* forms a barrier that shields the inhabited space from the potential threat of fog and water. In contrast, those vessels beyond the safe space established by *Starlight*'s horizontal delineation disappear in the mist.

Within the overall composition of *Ship Starlight in the Fog*, man's presence is minuscule. Only the ship, a vessel of man's design, serves as his visual mooring. Light, on the other hand, Lane seems to be suggesting, is the eternal essence—the spiritual, the sublime. This extraordinary work juxtaposes the real and the ideal, the specific and the universal, matter and light. Man's understanding of his diminutive role in relation to the uncharted vast-

ness of eternity does not inspire the fear evident in works painted later in the century, but a quiet elation.

Ironically, in the latter part of the nineteenth century, as man learned to create larger and safer sailing vessels, his sense of his ability to control the potentially chaotic forces of nature diminished. Stephen Crane's *A Man Adrift on a Slim Spar* resounds with a dark pessimism typical of late nineteenth-century sea imagery.

A man adrift on a slim spar
A horizon smaller than the rim of a bottle
Tented waves rearing lashy dark points
The near whine of froth in circles.
 God is cold.

The incessant raise and swing of the sea
And growl after growl of crest
The sinkings, green, seething, endless
The upheaval half-completed.
 God is cold.

A horizon smaller that a doomed assassin's cap,
Inky, surging tumults
A reeling, drunken sky and no sky
A pale hand sliding from a polished spar.
 God is cold.

The puff of a coat imprisoning air:
A face kissing the water-death
A weary slow sway of a lost hand
And the sea, the moving sea, the sea.
 God is cold.

This bleak work understands man as being adrift. The sea threatens upheaval, and God, the Hand, man's only hope for survival, is cold and offers no support.

In the work surveyed in this early period, the relationship of man to the sea evolves from one in which man is seen to enjoy a mastery of nature, a command over the quixotic forces of the sea, to one in which man and his constructs are at the mercy of the chaotic and destructive potential of the universe as epitomized by the sea. Many complex cultural forces contributed to this evolving image, not least of which were America's horrific experience of the Civil War and the uncertainties resulting from her entry into an international political and cultural arena. Similarly, Darwinian theories proposing that man was a mere participant in natural evolutionary processes, rather than the highest creation of a benevolent deity, greatly threatened man's sense of supremacy, his mastery of a known world and an assured place in it. The rise of urban centers and industrial technologies in America also contributed to feelings of powerlessness and alienation from nature. The nineteenth century witnessed a radical diminution in man's ability to perceive himself at the center of all things, as master of his world, as master of the sea.

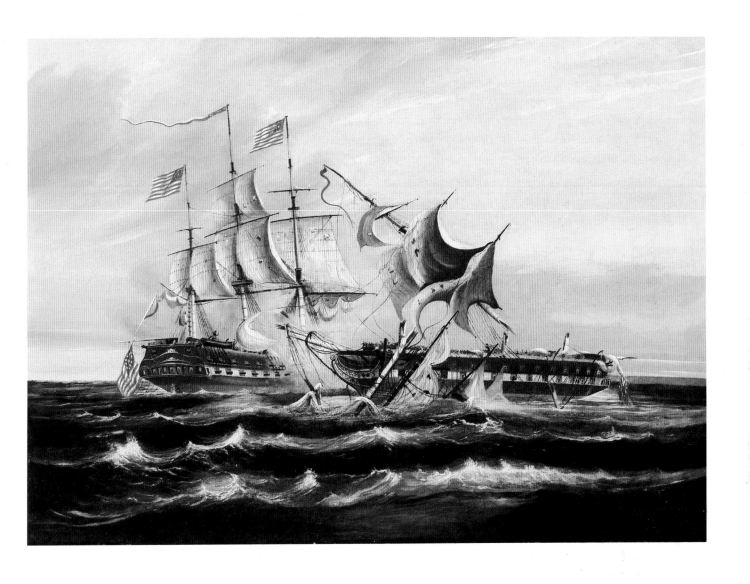

Thomas Chambers (1815–1866)

Capture of the Guerrière by the Constitution

Oil on canvas, 26 1/16 × 35 3/8 in.
Mead Art Museum, Amherst College,
Amherst, Massachusetts

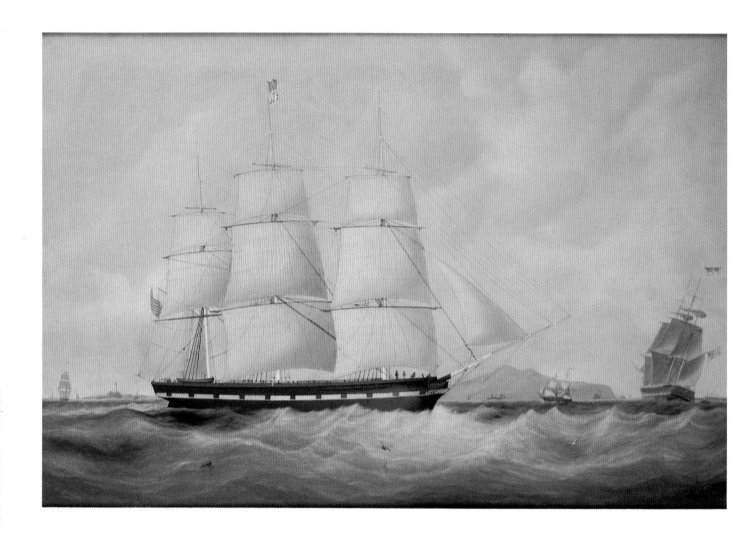

WILLIAM SMITH JEWETT (1812–1873)

Ship Huntress, 1855

Oil on canvas, 17 × 29 in.
The Butler Institute of American Art,
Youngstown, Ohio

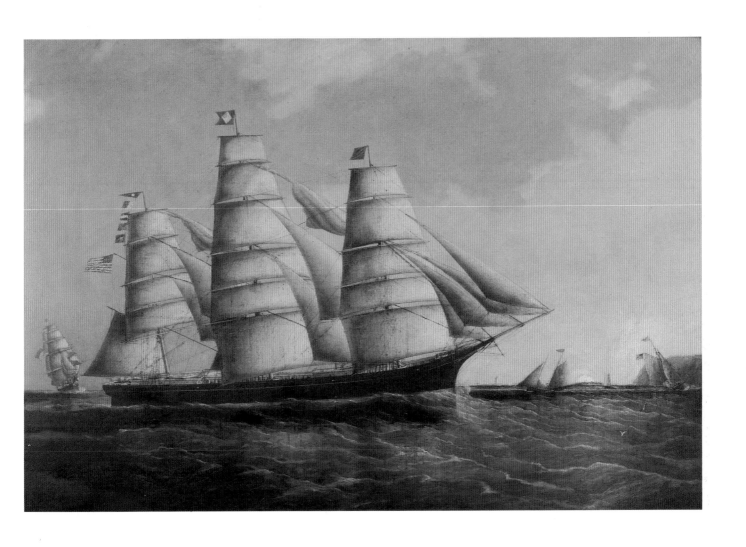

JAMES E. BUTTERSWORTH (1817–1894)

Ship Valparaiso

Oil on canvas, 24 × 36 in.
The Butler Institute of American Art,
Youngstown, Ohio

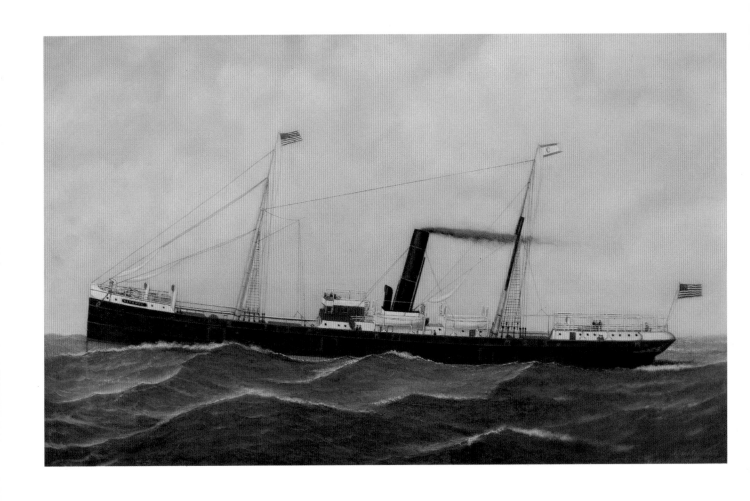

ANTONIO JACOBSEN (1850–1921)

Navahoe, Clyde Steamship Company, 1898

Oil on canvas, 22 × 36 in.
The Butler Institute of American Art,
Youngstown, Ohio

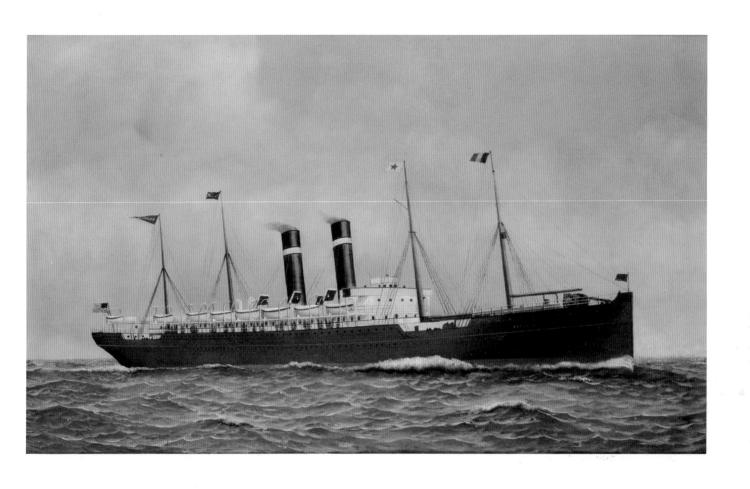

ANTONIO JACOBSEN (1850–1921)

Steamer Kroonland (Red Star Line), 1903

Oil on canvas, 30 × 50 in.
The Butler Institute of American Art,
Youngstown, Ohio

JAMES HAMILTON (1819–1878)

From Sail to Steam

Oil on canvas, 30 × 50 in.
The Butler Institute of American Art,
Youngstown, Ohio

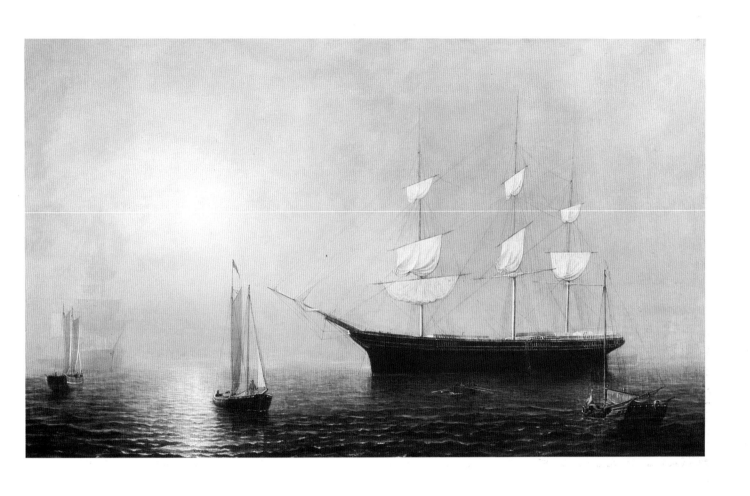

FITZ HUGH LANE (1804–1865)

Ship Starlight in the Fog, 1860

Oil on canvas, 30 × 50 in.
The Butler Institute of American Art,
Youngstown, Ohio

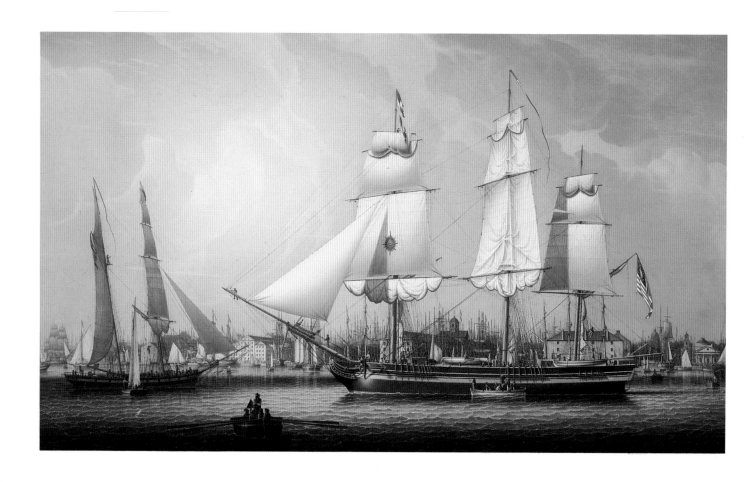

ROBERT SALMON (1775–c. 1845)

Wharves of Boston, 1829

Oil on canvas, 40 × 66½ in.
The Bostonian Society, Old State House, Boston;
Gift of Henry P. Quincy from the Estate of Edmund Quincy, 1894

The Harbor of Safe Retreat

With favoring winds, o'er sunlit seas,
We sailed for the Hesperides,
The land where golden apples grow;
But that, ah! that was long ago.

How far since then the ocean streams
Have swept us from the land of dreams,
That land of fiction and of truth,
The lost Atlantis of our youth!

Whither, ah, whither? are not these
The tempest-haunted Orcades,
Where sea-gulls scream, and breakers roar,
And wreck and sea-weed line the shore?

Ultima Thule! Utmost Isle!
Here in thy harbors for awhile
We lower our sails, awhile we rest
From the unending endless quest.

—from *Ultima Thule*
Henry Wadsworth Longfellow

Along with portraits of merchant sea captains and images of ships, harbor views are among the earliest seascapes produced in the United States. Emerging most likely from a topographical tradition in which accuracy, detail, and clarity were of utmost importance, the early painters and etchers of harbor vistas took great pains to present fully detailed representations of actual harbors in such bustling port cities as New York, Boston, Newport, and Charleston. These eighteenth- and early nineteenth-century works are characterized by a pride in the sophisticated, cosmopolitan nature of these relatively new ports, where ships from all over the globe gathered on their journeys to and from American waters.

Harbor views, popular in England throughout the eighteenth century, were first introduced in the United States through line engravings. The standard format for these works, derived from seventeenth-century Dutch prototypes, includes a panoramic presentation, horizontal delineation of sea and harbor spaces, and profusely detailed rendering of the ships in the harbor and of the buildings in the background port, which lends a sense of the familiar. Furthermore, an aura of comfort envelops the inhabited space at the journey's end. Harbor views, the most land-oriented works in marine painting, are almost pastoral in their safety and calm.

In nineteenth- and twentieth-century American literature, poets frequently present the harbor as an end to the sea journey—metaphorically a retreat from life's constant questing, a completion and realization of life's goals, or an escape from the torments of life as embodied by the sea. In *Ultima Thule* (see epigraph), Henry Wadsworth Longfellow portrayed the arrival at the "Utmost Isle" not as an attainment of life's goals but rather as a temporary surcease from constant efforts to achieve them.

Walt Whitman, in *The Beauty of the Ship*, suggested that the return to port is the completion of life's trials:

When, staunchly entering port,
After long ventures, hauling up, worn and old,
Batter'd by sea and wind, torn by many a fight,
With the original sails all gone, replaced,
 or mended,
I only saw, at last, the beauty of the Ship.

The visual arts of the nineteenth century usually present the harbor as a calm, enclosed sea space protected by landmasses, by the company of other ships, or by evidence of human habitation. In these works the presence or near-presence of land is reassuring. The harbor is literally and figuratively an escape from the perils of the sea journey.

One of the foremost painters of harbor views in the United States was Robert Salmon. Trained as a ship portraitist and as a painter of harbor views, Salmon had earned a considerable reputation in England before moving to this country in 1828, at the age of fifty-three. Evidence of his training in topographical rendering can be seen in *Wharves of Boston* of 1829 (p. 22), a painting that pays great attention to architectural and landscape detail. Similarly, his interest and grounding in the tradition of ship portraiture are evident in the broadside port view of the principal ship and in the rendering of the masts, sails, rigging, and hull construction.

Although profusely and accurately detailed, Salmon's works are never prosaic. He often used light and atmosphere to evoke serene tranquility within the safe retreat of the harbor. In *Wharves of Boston* the crisp delineation of waves, the placement of the vessels parallel to the picture plane, the alternation of light and dark patterning on the surface of the water (a formal device borrowed from Dutch seventeenth-century landscape and marine painting), and the low horizon line all form clearly discernible, strongly horizontal elements against which the prominent masts of the ships serve as a vertical counterfoil. This formal gridlike structure as well as the clarity of light and transparency of atmosphere suggest an order and harmony in the universe Salmon portrays. Despite being crowded with activity, a sense of serene calm prevails.

Robert Salmon's harbor views, masterful works in and of themselves, served as important influences on such younger American artists as Fitz Hugh Lane, Martin Johnson Heade, and William Bradford. A comparison of Lane's *Ship Starlight in the Fog* (p. 21) to Salmon's *Wharves of Boston* reveals Lane's indebtedness to Salmon in the proportional relation of ship to overall canvas space, the low placement of the horizon line, the off-center location of the principal focal point, and the clear rectilinear ordering of the composition in each. Most important, however, both artists share a profound interest in light as the embodiment of spirit, and both present the harbor as a place of safe retreat.

The harbor was not always presented as a place of quiet calm. In Edward Moran's *New Castle on the Delaware* of 1857 (p. 29), turbulent waters seethe at the entrance to the harbor as small vessels pitch about, clearly in danger of capsizing. The contrast of light and dark in the canvas and the zigzagging receding diagonals, both of which

derive from Dutch seventeenth-century proto-types, serve to enhance the drama of the narrative. The highlighting of land and the prominence of the church towers on the horizon suggest a happy conclusion to this stormy journey.

Among the chief influences on Moran's develop-ing style was the turbulent, storm-tossed seascape imagery of British artist J. M. W. Turner, whose work he certainly knew, at least through engravings if not originals. In *New Castle on the Delaware*, painted fairly early in his lengthy career, Moran's indebtedness to Turner is evident. Al-though the destructive potential of the sea is ever present in Moran's depiction, the port offers solace and escape, and hope for delivery from the turmoil of the sea journey.

In marked contrast to Moran's turbulent sea-scape is Francis A. Silva's *Schooner Passing Castle Island, Boston Harbor* of 1874 (p. 30). Although the vessels depicted in this work are well out in Boston harbor, there is no suggestion of danger. A sublime light emanates from the setting sun and fills the entire canvas with a sense of calm serenity. Best known for his harbor views, seascapes, and pastoral river scenes, Silva traveled frequently in the 1870s along the New England coast from Nar-ragansett Bay, Rhode Island, to Cape Ann, Mas-sachusetts, in search of compelling visual material. Following customary Hudson River school prac-tices, he executed pencil drawings and small oil sketches during these trips, later developing them into studio paintings. In his interest in composi-tional clarity and in the effects of light and atmo-sphere on the overall mood of a painting, Silva is clearly indebted to both John F. Kensett and Fitz Hugh Lane.

The harbor presented in Alfred Thompson Bricher's *The Landing, Bailey Island, Maine* of 1907 (p. 31) is an inlet sheltered by a nearby land-mass and an island somewhat farther off, but the harbor in William Bradford's *Afternoon on the Labrador Coast* (p. 32) is formed by a cluster of ships, islands, and icebergs, suggesting that "har-boring" is wherever men gather in mutual support. In both, calm waters, the cluster of vessels, the presence of human activity, and the open expanse of sky suggest a tranquil environment far removed from the perils evident in Edward Moran's *New Castle on the Delaware*. Both the Bricher and Bradford paintings were executed in the artists' stu-dios from preliminary studies done at the sites.

Bricher painted numerous canvases depicting the Maine coast, from Grand Manan Island to Port-land Head, in different seasons and in varying light conditions. In 1907 he painted extensively along Casco Bay and particularly on Bailey Island in the area of Brunswick, approximately fifty miles north of Portland. In *The Landing, Bailey Island, Maine*, smoke from the chimneys of tiny houses huddled on the shore, human activity on the wharf, and even the broad, painterly rendering of the pebbles on the beach lend a sense of safe familiarity to this most idyllic harbor image. Although the point of land visually directs the eye outward, it is the har-bor in its dark clarity and weight that offers safe mooring.

William Bradford accompanied several explora-tory expeditions to northern polar regions between the mid-1850s and 1869. During these trips he ex-ecuted pencil sketches and took photographs that he later used as preliminary studies for paintings. In *Afternoon on the Labrador Coast*, a spit of land to the right of the canvas anchors the composition, but ironically, it is the iceberg at middle distance and the constellation of vessels in the foreground that create the sense of a harbor. In spite of the presence of the massive iceberg, the implication of human activity renders this harbor safe and secure. Undoubtedly, the open expanse of sky and the sunny atmosphere augment the overall feeling of

security in this canvas. Even the solitary figure paddling his kayak toward the larger vessel seems safe in these calm waters.

In both John F. Kensett's *Shore Line in Summer* (p. 33) and Martin Johnson Heade's *Salt Marsh Hay* of c. 1865–75 (p. 34) the suggestion of human interaction with the sea is very subtle indeed. Kensett alludes to human presence only through the inclusion of the sails of tiny vessels far out in the harbor. The vessels are well protected, however, by a distant, barely discernible spit of land, which extends the full width of the canvas and shelters the entire harbor from the potential ravages of the open sea.

In *Shore Line in Summer*, the broad expanse of sky and water, the asymmetrical composition, and the general feeling of serenity and clarity are typical of Kensett's mature work. The loose handling of paint, especially in the foliage and rocks in the foreground, suggests that this painting was a preliminary sketch rather than a finished picture. In this delicate, pastoral seaside vista, Kensett presents the harbor as a safe and tranquil space far from the turbulence of open waters.

Versatile and widely traveled, Martin Johnson Heade throughout the 1840s executed academic portraits, genre scenes, and landscape paintings according to Hudson River school conventions. Heade spent his summers sketching in Rhode Island along Narragansett Bay, along the coast of Maine, in New Hampshire, or near the salt marshes around Newburyport, Massachusetts. In *Salt Marsh Hay*, the simple horizontal composition and the reduction of visual detail evoke an overall sense of serenity, which is imperiled by an approaching storm. But the solidity of the haystacks visually anchors the composition; these massive stacks will surely survive the gale. In this poetic vision, Heade seems to be suggesting that despite the safety of this idyllic vista, to live and

work near the sea exposes man to the quixotic forces of nature. Man's industry, represented by the stability of the haystacks, serves as a foil to nature's fury.

Robert Henri, along with fellow members of The Eight—Everett Shinn, William J. Glackens, George Luks, John Sloan, Maurice Prendergast, Ernest Lawson, and Arthur B. Davies—found in scenes of contemporary urban life a dynamism, energy, and vitality that epitomized the new spirit of the twentieth century. Appropriately, when Henri painted the sea, it was to the seething energy of the port of New York City that he turned.

Hudson River Docks of c. 1900–10 (p. 35) is a work far removed both from the pastoral imagery of Heade and Kensett and from the crisply detailed rendering of nineteenth-century ship portraits. Henri's true subject is the vitality of the smoke- and haze-shrouded port of New York. Here details of rigging and ship architecture, important to ship portraitists, give way to a more impressionistic rendering of urban energy, a vital force that overwhelms precise description. In *Hudson River Docks* Henri depicts the urban port, a place where two worlds meet—one of throbbing energy, the other of quiet calm. Henri contrasts the cacophonous activity and congestion of the docks and the decks, and the apartment towers looming in the distance, with the serene, evocative atmosphere of the river.

In George Bellows's *An Island in the Sea* of 1911 (p. 36), a large landmass establishes the shelter of a harbor and protects the tiny boats from the ravages of the sea. In 1911 Bellows and Robert Henri, with whom he studied, spent the summer together on Monhegan Island, Maine. *An Island in the Sea* was painted during this summer sojourn. Throughout his career Bellows frequently painted the sea, presenting it most often as a violent and destructive force. Here, however, the sea appears tranquil and

luminous, the landmass dominating the image. Broadly painted, the dark rock island seems almost spectral as it cuts across the vertical line of moonlight reflected on the ocean's surface. Bellows seems to suggest that man's creations, his homes and his vessels, are inconsequential in contrast to the magnitude and mystery of natural phenomena.

The port Stuart Davis presents in *Gloucester Harbor* of 1924 (p. 37) is calm, ordered, and clearly delineated by strong horizontals and verticals tipped into one plane. The sailing ship at the pier is seen behind a warehouse and a building near the dock, and is suggested only by its mast and rigging; the ship's purpose is humorously alluded to, however, by the sign on the warehouse. In this work the sea poses little threat, for the composition of architectural and linear forms suggests more of the land than the sea.

About 1917 Davis began experimenting with cubism, which he had first encountered in the Armory Show in the work of Pablo Picasso and Georges Braque. This painting reflects something of the analytical cubism that Davis used from 1920 on, under the particular influence of both Fernand Léger and Picasso, to broaden his imagery into simple, interlocking planes of color within clearly ordered, formally structured compositions. Throughout his career, Davis painted cityscapes and landscapes that reflect the vitality of the twentieth-century urban scene.

Like Robert Henri, Reginald Marsh, in *Along the Waterfront* (p. 38) and *The Normandie* (p. 39), both of 1938, was captivated by the activity and energy of a vital urban port. Throughout the late 1930s Marsh frequently painted New York harbor scenes and dockside views. Many of these works were preliminary studies for his 1937 mural for the Customs House in New York City. In multiple panels Marsh depicted the successive stages in the arrival of an ocean liner in the port of New York—

passing Ambrose Channel Lightship, the harbor pilot boarding the ship, passing the Statue of Liberty, unloading the passengers and cargo.

Along the Waterfront and *The Normandie*, both executed a year after Marsh completed the mural cycle, suggest his continuing interest in port activities. In *Along the Waterfront* Marsh chose a quiet moment prior to unloading the cargo, before the flurry of human activity. In this respect, the work is unusually serene for Marsh's dockside subjects. By contrast, *The Normandie* almost bursts with energy. The forward surge of the tug in the harbor is perfectly paralleled by the striding gait of the female figure on the shore. Marsh's sketchy rendering enhances a sense of excitement and dynamism.

The harbor Ivan Albright presents in *The Harbor of Dreams* of 1941 (p. 40) is remote, one in which the only allusions to a human community are seen in dinghies and lobster pots. Albright is known as a painter of highly detailed, often grotesque images of human figures, landscapes, and still lifes; the mysterious, lyrical portraiture of Charles Hawthorne had a profound influence on him as a young artist.

The Harbor of Dreams was most likely executed at either Deer Isle or Cundy's Harbor, Maine, where Albright spent the summer of 1941. The choppy, staccato rendering of the water and foliage, differing considerably from the meticulous detailing of Albright's studio pictures, lends the outdoor sketch a vitality and buoyancy not always apparent in his finished pictures. The nature of the dreams alluded to in the title is unclear, but it is certain that the artist found the sea moody and evocative. For Albright, even within the safe confines of the harbor, the ineffable realm of the unconscious persists. Albright's impressionistic rendering in broad strokes of strong color adds a nervous energy to the sky, land, and water. The only escape from this visual turbulence lies in the

more broadly painted forms of the dinghies. The ships are both vehicles for transport and safe moorings in a harbor.

Fairfield Porter's *Boathouses and Lobster Pots* of 1968–72 (p. 41) glows with the radiance of a warm summer's day in Maine. While the harbor is broadly presented and serene, the lobster boats appear as silhouettes in the water. The high horizon line, the image of land enveloping water, and the central placement of the boathouses form a most secure seascape image. Porter portrayed the inlet as a sunny, safe harbor remote from the ravages of the sea.

In 1938 Porter saw at the Art Institute of Chicago an exhibition of the paintings of Edouard Vuillard and Pierre Bonnard that had a profound impact on his developing artistic style. Porter responded to the painterly realism, orderliness, and poetically evocative intimacy apparent in the work of both artists. Like them, Porter found beauty and poetry in the simple everyday activities around him.

Throughout the nineteenth and twentieth centuries, artists and writers commonly emphasized both the destructive potential of the sea and the power of nature. They began to depict the harbor more frequently as a place of escape, a retreat from the perils of the sea journey. In the harbor the proximity of land and the company of other ships reassure both visually and psychologically. For many of the artists discussed here, including Bricher, Kensett, and Porter, the harbor is a safe place, sunny and secure, radiating an aura of bucolic calm. For others, such as Bradford, Henri, and Marsh, it is the human activity in the port—the human community—that makes it a safe space. For still others, such as Bellows and Albright, the harbor is a place of temporary respite, one in which man's efforts and constructs seem puny in contrast to the magnitude of natural forces.

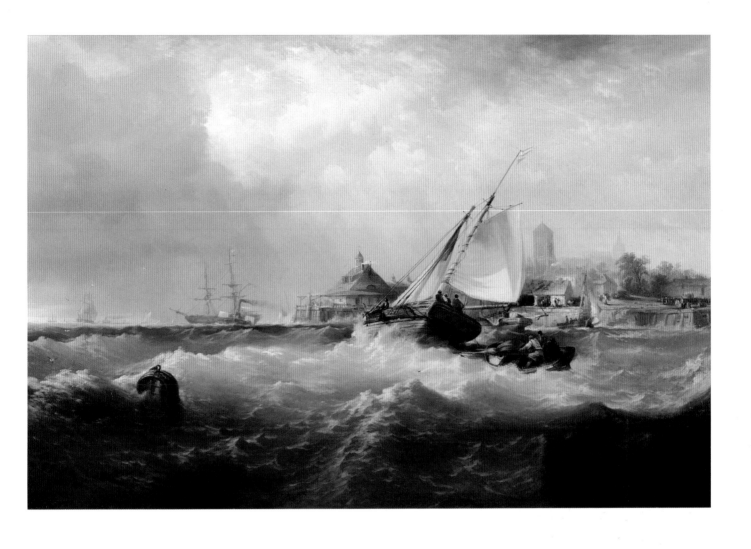

EDWARD MORAN (1829–1901)

New Castle on the Delaware, 1857

Oil on canvas, 40 × 60 in.
The Butler Institute of American Art,
Youngstown, Ohio

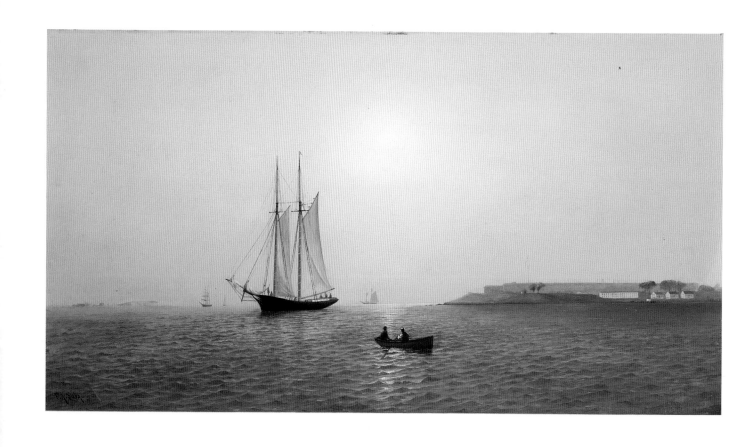

FRANCIS A. SILVA (1835–1886)

Schooner Passing Castle Island, Boston Harbor, 1874

Oil on panel, 22 × 38 in.
The Bostonian Society, Old State House, Boston;
Gift of Mrs. Vernon A. Wright, 1939

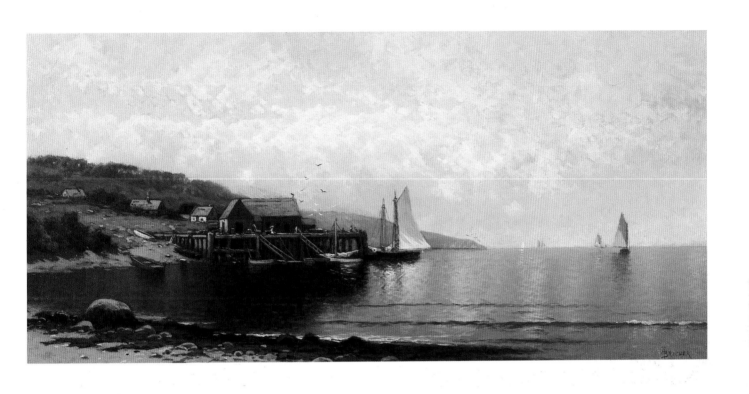

ALFRED THOMPSON BRICHER (1837–1908)

The Landing, Bailey Island, Maine, 1907

Oil on canvas, 15 × 32 in.
The Butler Institute of American Art,
Youngstown, Ohio

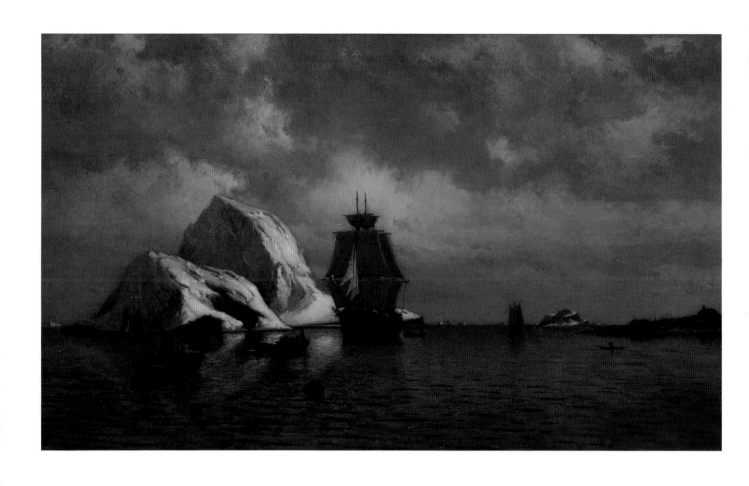

WILLIAM BRADFORD (1823–1892)

Afternoon on the Labrador Coast, 1878

Oil on canvas, 28 × 48 in.
The Butler Institute of American Art,
Youngstown, Ohio

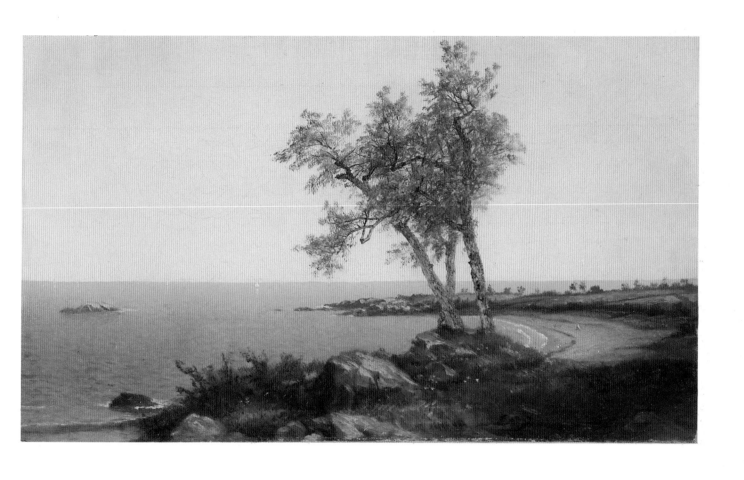

JOHN F. KENSETT (1816–1872)

Shore Line in Summer

Oil on canvas, 17 × 29 in.
The Butler Institute of American Art,
Youngstown, Ohio

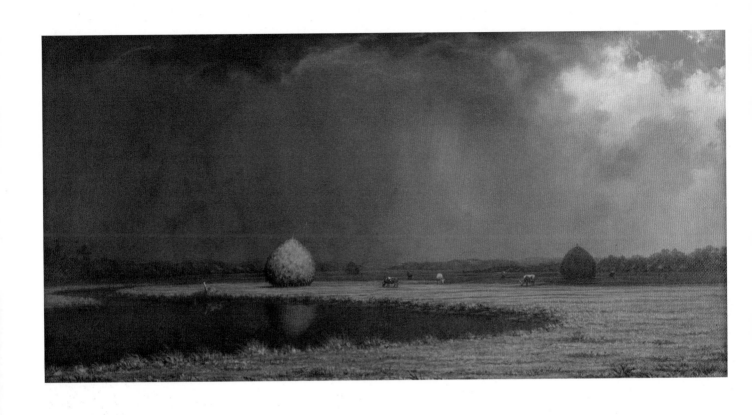

MARTIN JOHNSON HEADE (1819–1904)

Salt Marsh Hay, 1865–75

Oil on canvas, 13 × 26 in.
The Butler Institute of American Art,
Youngstown, Ohio

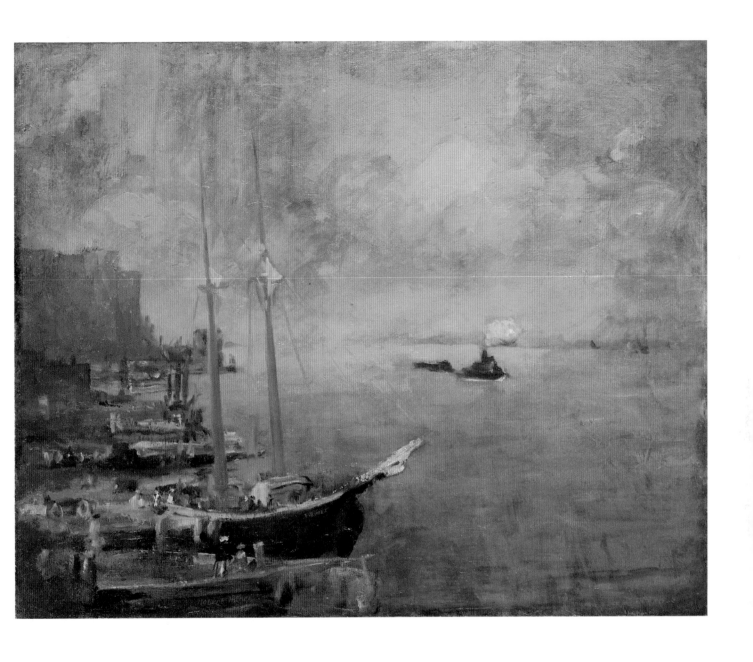

ROBERT HENRI (1865–1929)

Hudson River Docks, c. 1900–10

Oil on canvas, 28 × 32 in.
Mead Art Museum, Amherst College,
Amherst, Massachusetts

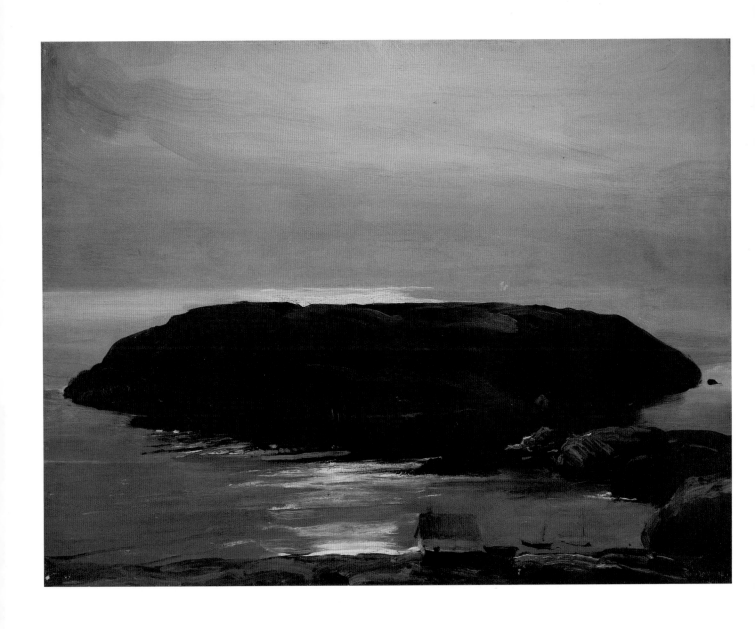

GEORGE BELLOWS (1882–1925)

An Island in the Sea, 1911

Oil on canvas, 34¼ × 44⅜ in.
Columbus Museum of Art, Columbus, Ohio;
Gift of Howard B. Monett

STUART DAVIS (1894–1964)

Gloucester Harbor, 1924

Watercolor and crayon on paper, 13 × 18 in.
The Butler Institute of American Art,
Youngstown, Ohio

REGINALD MARSH (1898–1954)

Along the Waterfront, 1938

Watercolor on paper, 14 × 20 in.
The Butler Institute of American Art,
Youngstown, Ohio

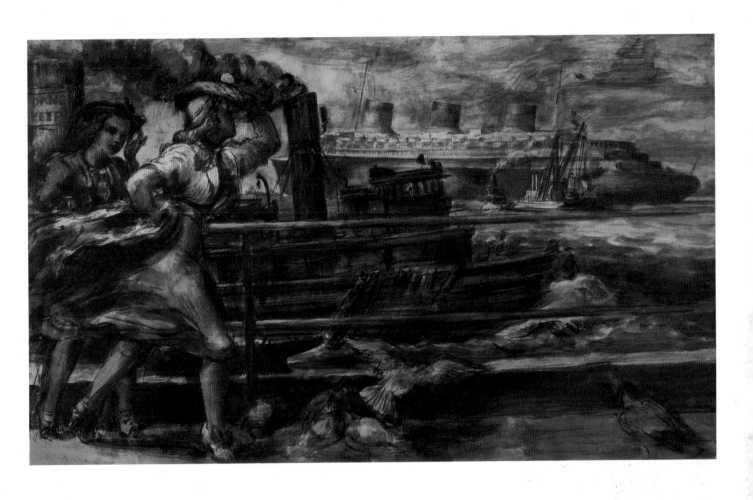

REGINALD MARSH (1898–1954)

The Normandie, 1938

Watercolor on paper, 30 × 50 in.
The Butler Institute of American Art,
Youngstown, Ohio

IVAN ALBRIGHT (1897–1983)

The Harbor of Dreams, 1941

Watercolor on paper, 13 × 19 in.
The Butler Institute of American Art,
Youngstown, Ohio

FAIRFIELD PORTER (1907–1975)

Boathouses and Lobster Pots, 1968–72

Oil on canvas, 48 × 60 in.
Mead Art Museum, Amherst College,
Amherst, Massachusetts

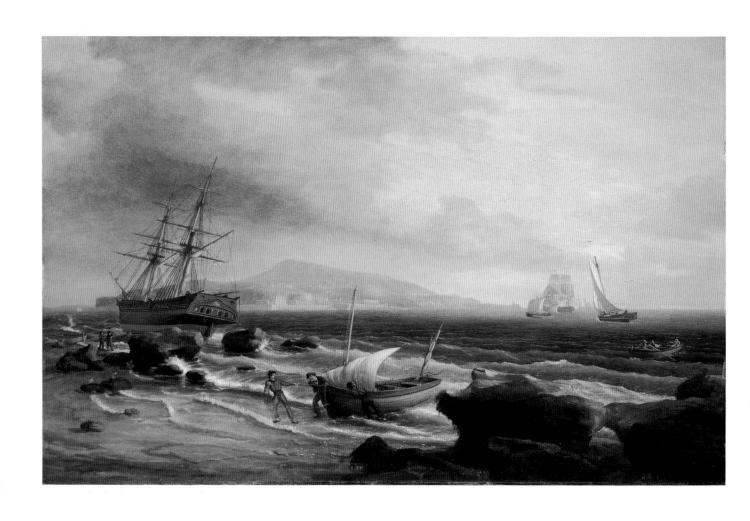

The Power of the Sea

The shattered water made a misty din.
Great waves looked over others coming in,
And thought of doing something to the shore
That water never did to land before.
The clouds were low and hairy in the skies,
Like locks blown forward in the gleam of eyes.
You could not tell, and yet it looked as if
The shore was lucky in being backed by cliff,
The cliff in being backed by continent;
It looked as if a night of dark intent
Was coming, and not only a night, an age.
Someone had better be prepared for rage.
There would be more than ocean-water broken
Before God's last Put out the Light *was spoken.*

—*Once by the Pacific*
Robert Frost

The sea as an abstract, elemental force possessing the power to destroy man and all his creations became a subject of increasing interest to artists and writers throughout the nineteenth and into the twentieth centuries. In numerous works of the past one hundred years, man is no longer depicted as holding dominion over the sea; rather he is subject to the quixotic, often destructive forces of nature and buffeted by forces too irrational to comprehend. In some works the sea wreaks havoc with sailing vessels, washing them ashore or tossing them about like toys. In others, man himself is washed ashore dead or dying, utterly destroyed by violent waters. Some artists metaphorically juxtapose sea and land as two primordial elements locked in a raging battle between the power to destroy and the endurance to persist. In these later works, man plays no role other than as observer of this unending conflict. In all such works, the power and destructive potential of the sea are the artist's true subject.

Images suggesting the power of the sea abound in nineteenth- and twentieth-century American literature. In this excerpt from Ralph Waldo Emerson's *Sea-Shore*, the sea asserts its power in its own anthropomorphized voice.

I with my hammer pounding evermore
The rocky coast, smite Andes into dust,
Strewing my bed, and, in another age,
Rebuild a continent of better men.
Then I unbar the doors: my paths lead out
The exodus of nations: I disperse
Men to all shores that front the hoary main.
I, too, have arts and sorceries;
Illusion dwells forever with the wave.
I know what spells are laid. Leave me to deal

With credulous and imaginative man;
For, though he scoop my water in his palm,
A few rods off he deems it gems and clouds.
Planting strange fruits and sunshine on the shore,
I make some coasts alluring, some lone isle,
To distant men, who must go there, or die.

For Emerson, the sea can be a benign as well as a powerful force, a source of nurture for the body, imagination, and spirit. Man is small in contrast to the ocean's magnitude, but its beneficence outweighs its dangers.

By contrast, Robert Frost's *Once by the Pacific* (see epigraph) underscores the sea's power and capacity to destroy. He suggests, however, that the sea's awe-inspiring capabilities are insignificant in comparison to the rage that will destroy more than water does; by "dark intent," Frost may very well allude to man's new-found ability to devastate the earth through nuclear weapons.

In *A Broad Harbor* of 1844 (p. 42), Thomas Birch portrays a ship run aground in a rocky harbor in the wake of a departing storm. It was most likely from the French artist Claude Joseph Vernet that Birch developed his profound interest in the image of the shipwreck. Always dramatic in presentation, Birch's shipwreck scenes underscore man's vulnerability in the face of nature's destructive potential. The constant threat of ruin is visually reinforced by the prominent placement of boulders and rock formations in the foreground of the canvas.

In Russell Smith's *Seascape* of 1867 (p. 47), the malevolent sea has done its work, and the human wrack—a human body—lies washed up on the shore. Smith developed a considerable reputation as a painter of dramatic, pathos-charged landscapes. In *Seascape*, the architectural detailing of the cliffside suggests Smith's awareness of European architecture and painting traditions, and its dramatic lighting and theatricality were influenced

by the artist's early work as a set designer. In this work, the power of the sea appears epic, as a vertical headwall of rock confronts a horizontal sweep of wave and serves as a vivid backdrop to the human tragedy on the shore.

Epic destructiveness takes on religious connotations in poet and painter Marsden Hartley's *Fishermen's Last Supper*, a dark tribute to drowned seafarers (Hartley also explored the subject in a painting of the same name). The poem describes the sea as a cold-blooded murderer, a dispassionate destroyer:

For wine, they drank the ocean —
for bread, they ate their own despairs;
counsel from the moon was theirs
for the foolish contention.

Murder is not a pretty thing
yet seas do raucous everything
to make it pretty —
for the foolish or the brave,
a way seas have.

Also suggestive of the power of the sea is Robert Swain Gifford's *Cliff Scene, Grand Manan* of 1865 (p. 48). The alternating areas of light and dark and the crisscrossing lines formed by the masts in the middle distance recall Gifford's indebtedness to Dutch marine traditions and undoubtedly to Albert Van Beest, the Dutch-American painter with whom he had studied. The struggle of the fishermen hauling in the nets through the turbulent waters suggests the sea's power and man's diminished role in relation to nature's magnitude.

In Harrison Brown's *Coast of Maine* (p. 49), an epic drama, devoid of man, unfolds in the clash between the surging force of the water and the ponderous weight of the rock. Brown is best known as a seascape painter and often painted around Casco Bay near Portland, Maine. Nature's vulnerable aspect is suggested only in the gulls that almost

seem to be fleeing this great battle to search for calmer waters. The vertical massing of rock on the right of the canvas acts as a stabilizing counterfoil to the churning waters and foggy skies along this rugged coast.

William Trost Richards's solid grounding in accurate draftsmanship was augmented by his early work between 1850 and 1854 as a designer of ornamental metalwork. Richards was profoundly influenced by the romantic/realist vision of the Hudson River school. Recognized for his landscapes and marine vistas, Richards painted frequently along the coast of Conanicut Island in Rhode Island's Narragansett Bay. The choppy surf in *Conanicut Shore*, c. 1880s (not illustrated), and the lack of vegetation suggest that Richards may have painted this oil sketch at Beaver Tail, the island's southernmost point. *Conanicut Shore* and *Icart Bay, Sark*, c. 1890 (p. 51), both approximately 9 by 16 inches (a size that fits easily into the painter's carrying case), were most likely executed on location as preliminary studies for later studio pictures.

In pursuit of increasingly varied and dramatic marine vistas, Richards traveled frequently, from the 1870s through the 1890s, to Ireland, Scotland, and England, where he found the Channel Islands and the rugged coast of Cornwall particularly appealing. He executed numerous small sketches such as *Icart Bay, Sark* on location. Although the work is small, the loose, painterly handling captures much of the power and energy of the rough coastline, an energy sometimes missing from his more finished pictures. Epic both in its scale and subject, *Land's End, Cornwall* of 1888 (p. 50) is typical of Richards's majestic vertical compositions executed in the late 1880s. As does Harrison Brown, Richards suggests that perhaps even nature's own, the gulls, flee from the furious assault of the sea on the cliffs. The never-ending clash of water against rock—the primitive fury of nature in this primordial place—is the true subject of

Richards's work. By emphasizing the cliff's sheer verticality and planar stability in the face of the ocean's relentless assault, Richards underscores the headland's unyielding aspect.

Winslow Homer is considered this country's foremost painter of the sea. In 1881, after a varied career as lithographer, illustrator, and artist-correspondent for *Harpers Weekly* during the Civil War, Homer moved to England, where he remained for two years working in Cullercoats, a small fishing village on the North Sea. There he executed many watercolor studies depicting the harsh lives of the North Sea fishermen and their families. In these works Homer portrays the fortitude and bravery of these stoic people in their unrelenting battle with the forces of the sea. On his return to the United States in late 1882, he expanded on the themes first explored in these works in larger oil paintings developed in his studio. In 1884 Homer moved permanently to Prout's Neck, Maine, a small, rocky peninsula approximately five miles south of Portland; there he produced most of his finest seascapes.

In his earliest work at Prout's Neck, Homer explored the relationship between man and nature by juxtaposing small human figures with the panorama of the sea. Gradually through the 1880s, the human figure disappears from these compositions, and the struggle of ocean and land emerges as his principal subject.

In Homer's *Moonlight, Wood Island Light* of 1894 (p. 52), the sea is presented as a relatively tranquil force, expansive yet unthreatening. The moonlight glow on the ocean's surface reinforces the mood of calm tranquility. The only reference to man and his creations appears subtly in the tiny dots of red light in the far distance, the beams from the Wood Island lighthouse. Through this allusion, man seems minuscule in relation to the sea's magnitude. According to William Howe Downs, in his 1911 biography of the artist, Homer executed this

painting in an uninterrupted five-hour sitting, with the moon as his only light source.

The ocean Homer presents in *Maine Coast* of 1896 (p. 53), also painted at Prout's Neck, is much less placid, more charged with power and destructive potential. The dramatic distinction between the two works owes in part to the artist's vantage point. In *Moonlight, Wood Island Light*, Homer was looking westward toward the calmer waters of the bay sheltered by Prout's Neck itself, whereas in *Maine Coast*, his view was directly eastward toward the wilder, unsheltered Atlantic surf. As in all of his most powerful works of this period, Homer uses the sea—waves pounding against raw rock—as a metaphor for the unfathomable power of nature.

In Emil Carlsen's *The Surf* of 1907 (p. 54), the clash of water against rock assumes a less violent, more poetically evocative tone. On a trip to France in 1875, Carlsen studied the work of the eighteenth-century French still-life painter Jean-Baptiste-Siméon Chardin, whose compositional simplicity and allusive content became an important influence. Between 1884 and 1886, during a second visit to Paris, Carlsen became aware of impressionism and the impressionist-influenced landscape imagery of the American painter Willard Leroy Metcalf.

Carlsen painted seascapes often throughout his career. His marine vistas, as in *The Surf*, were most frequently unpeopled. In this painting the low placement of the horizon line allows Carlsen to make the most effective use of the misty tonalities of the sky. Similarly, the asymmetrical balancing of solid rocks in the foreground against the receding waters in the distance lends a quietly poetic mood to the canvas.

Frederick J. Waugh had a solid grounding in academic drawing and figure painting. He painted portraits, genre scenes, and landscapes until 1893 when, while vacationing on the island of Sark in the English Channel, he first turned his attention to marine subjects. He lived with his family in St. Ives, the artists' colony in Cornwall, England, from approximately 1895 to 1907, when he returned to the United States and settled in Montclair, New Jersey. Waugh frequently spent his summers painting along the Maine coast, particularly at Monhegan Island and Bailey Island.

In *Breakers at Floodtide* of 1909 (p. 55), Waugh's typical use of thick pigment suggests the power of the pounding surf. The close-up point of view, as the artist (and viewer) stands presumably ankle-deep in the retreating surge, makes the sea's power seem all the more imposing. As it floods across the ocean's choppy surface, the moonlight creates an aura of quiet reverie that calms the sea's threatening aspect.

Throughout the nineteenth and into the twentieth centuries, some artists and poets underscored the destructive potential of the sea. Birch and Smith saw in nature's fury the capability of destroying man and all his creations, while others, such as Brown and Richards, presented the epic battle of sea and rock as a conflict remote from the human community and human content. In all these works, the pure, elemental power of the sea is the artist's true subject.

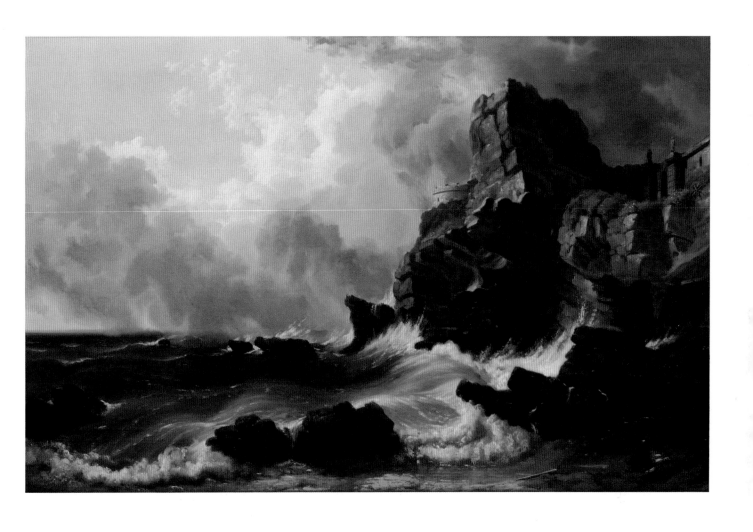

RUSSELL SMITH (1812–1896)

Seascape, 1867

Oil on canvas, 34 × 56 in.
The Butler Institute of American Art,
Youngstown, Ohio

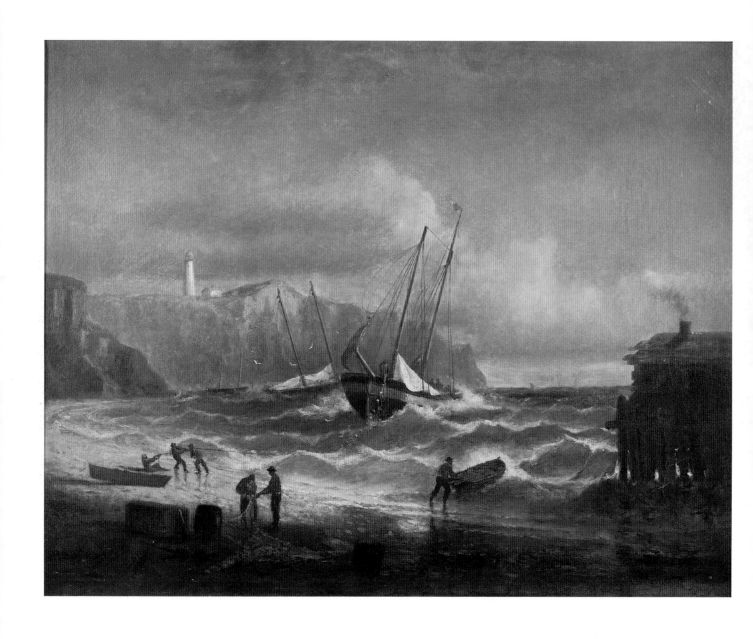

ROBERT SWAIN GIFFORD (1840–1905)

Cliff Scene, Grand Manan, 1865

Oil on canvas, 21 × 26 in.
The Butler Institute of American Art,
Youngstown, Ohio

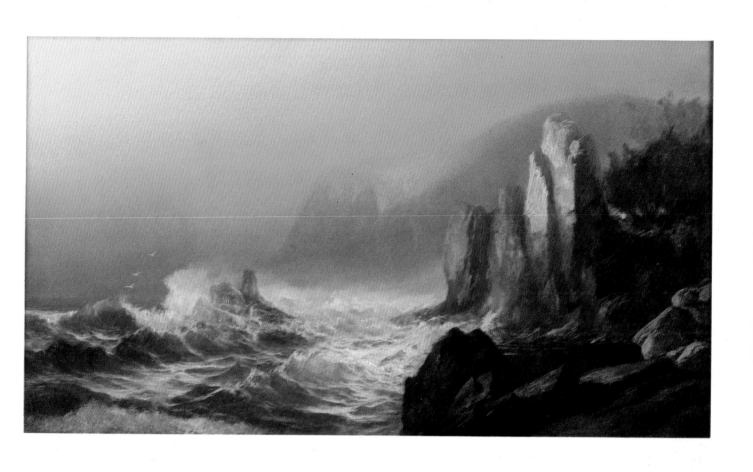

HARRISON BROWN (1831–1915)

Coast of Maine

Oil on canvas, 13 × 23 in.
The Butler Institute of American Art,
Youngstown, Ohio

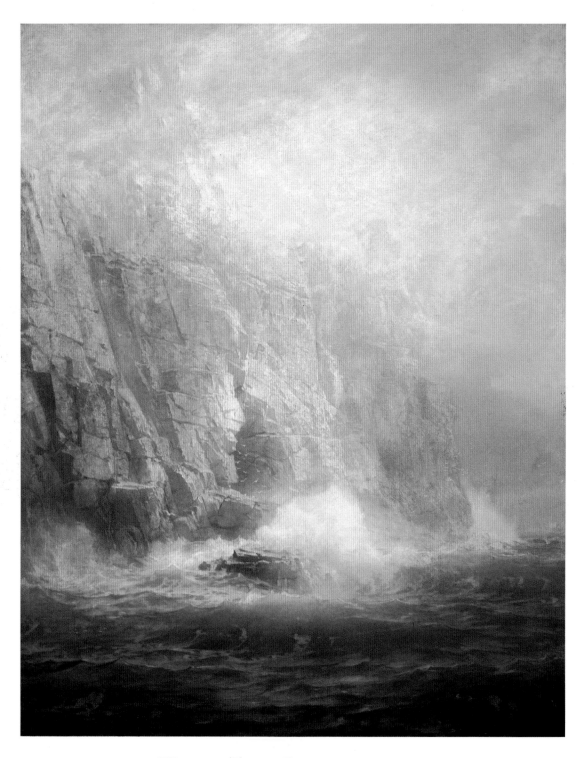

WILLIAM TROST RICHARDS (1833–1905)

Land's End, Cornwall, 1888

Oil on canvas, 62 × 50 in.
The Butler Institute of American Art,
Youngstown, Ohio

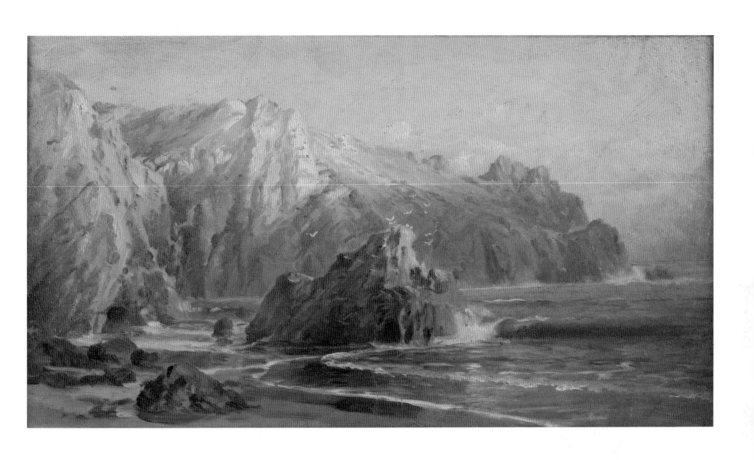

WILLIAM TROST RICHARDS (1833–1905)

Icart Bay, Sark, c. 1890

Oil on canvas, 9 × 16 in.
The Butler Institute of American Art,
Youngstown, Ohio

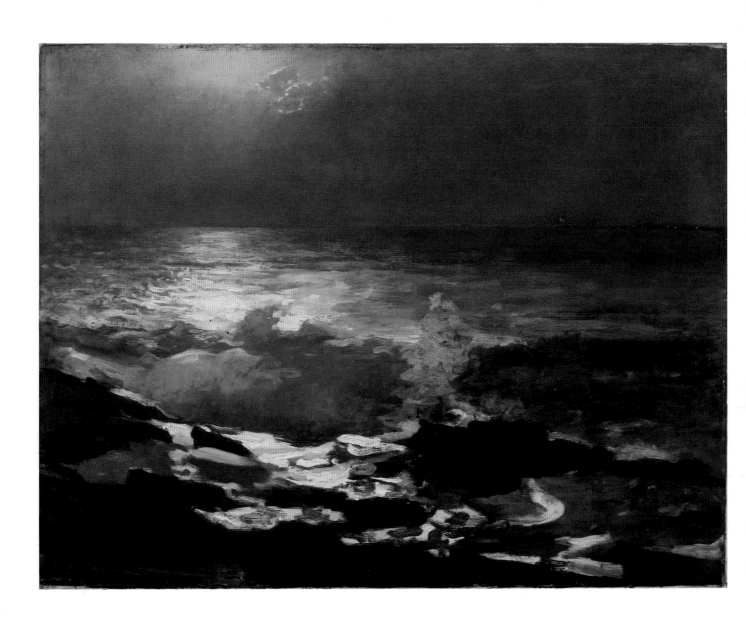

WINSLOW HOMER (1836–1910)

Moonlight, Wood Island Light, 1894

Oil on canvas, 30¾ × 40¼ in.
The Metropolitan Museum of Art, New York

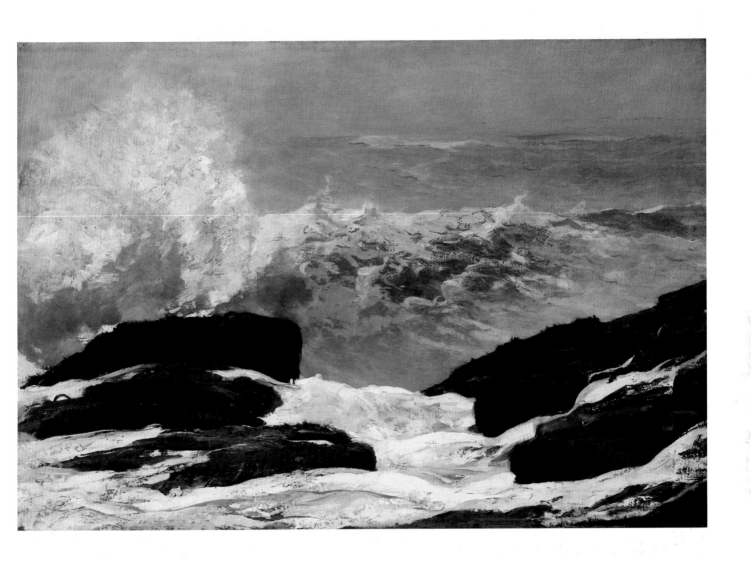

WINSLOW HOMER (1836–1910)

Maine Coast, 1896

Oil on canvas, 30 × 40 in.
The Metropolitan Museum of Art, New York

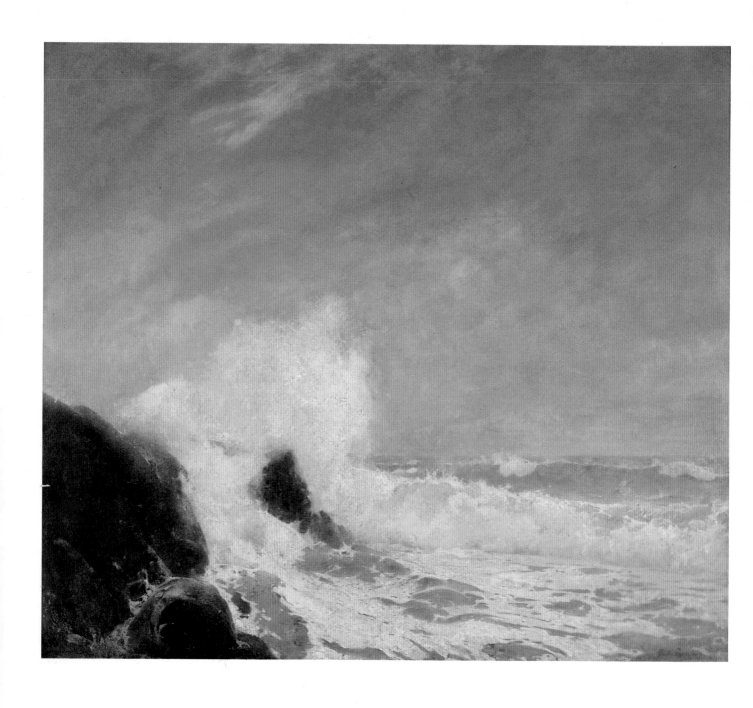

EMIL CARLSEN (1853–1932)

The Surf, 1907

Oil on canvas, 64 × 74 in.
The Butler Institute of American Art,
Youngstown, Ohio

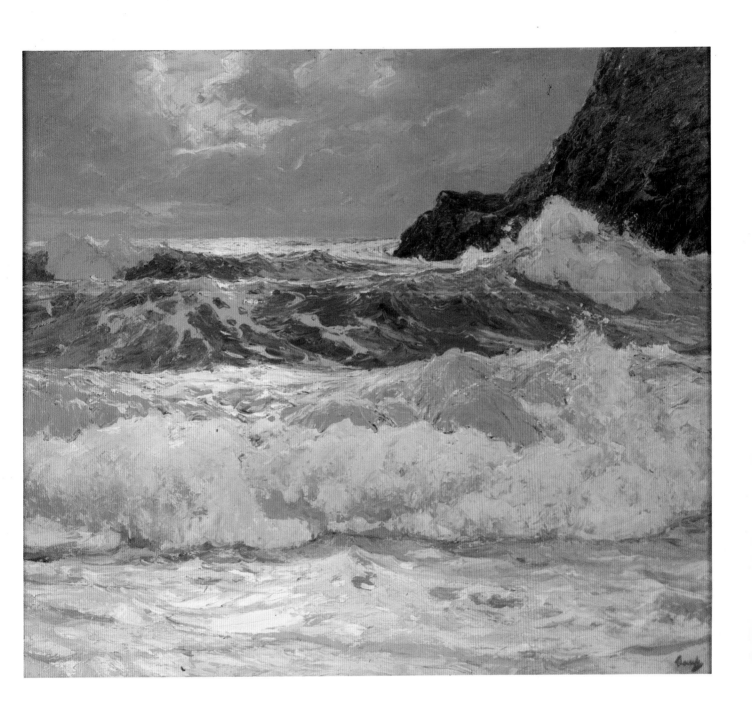

FREDERICK J. WAUGH (1861–1940)

Breakers at Floodtide, 1909

Oil on canvas, 35 × 40 in.
The Butler Institute of American Art,
Youngstown, Ohio

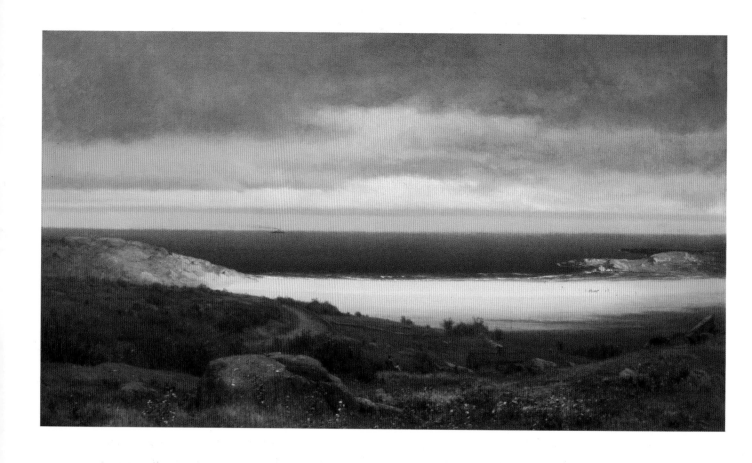

JERVIS McENTEE (1828–1891)

Seaside Landscape, 1873

Oil on canvas, 24 × 28¾ in.
Mead Art Museum, Amherst College,
Amherst, Massachusetts

By the Sea

Sea of stretch'd ground-swells,
Sea breathing broad and convulsive breaths,
Sea of the brine of life and of unshovell'd yet always-ready graves,
Howler and scooper of storms, capricious and dainty sea,
I am integral with you, I too am of one phase and of all phases.

—from *Song of Myself*
Walt Whitman

Beginning about 1870, as a new prosperity and internationalism emerged in the aftermath of the Civil War, Americans in unprecedented numbers began to travel to the shores to swim, play, or simply promenade by the sea. Just as their counterparts in Europe flocked to the coastal resorts of Venice, Trouville-sur-Mer, Deauville, Dieppe, Etretat, and Brighton, Americans began to holiday at Nahant, Narragansett, Gloucester, Newport, and Atlantic City.

During this period many American artists began to portray man's new, more playful relationship to the ocean. In such works the ocean is often depicted as friendly and unthreatening. Skies are open and expansive; sunlight floods the spaces depicted. The scenes are peopled by observers who sit, stand, or saunter by the sea, unmindful of its destructive capabilities. Men and women are seen enjoying a harmonious and fully integrated relationship to nature, neither overwhelmed nor overawed by its grandeur. The figure of man looms larger in pictorial space as artists present a more even balance between the human and the natural spheres. A strong note of buoyant optimism characterizes the work of this time.

Numerous nineteenth- and twentieth-century American essayists and poets place their subjects by the sea to suggest harmonious as well as discordant images of the universe. In *Song of Myself* (see epigraph), Walt Whitman senses the sea's ambivalence but seeks a compatible relationship with it.

In Jervis McEntee's *Seaside Landscape* of 1873 (p. 56), man is still seen as small and nature grand. Throughout the 1860s McEntee spent his summers sketching in the Adirondacks and the Catskills. Returning to the United States by the early 1870s after a European sojourn, McEntee went on a sketching tour along the Massachusetts coast with Worthington Whittredge and Sanford Robinson Gifford in the summer of 1872, returning to New York via Fall River, Massachusetts, and Newport, Rhode Island.

Seaside Landscape was most likely painted in McEntee's studio after studies executed during this summer trip. Produced at a turning point in his career, this painting—in its panoramic vision of the landscape and its precise detail—is still closely tied to the Hudson River school traditions in which man appears dwarfed by the enormity of nature. Starting in the mid-1870s, McEntee began to develop a more intimate landscape style. The seasonal landscape subjects, painterly rendering, and

poetically evocative mood of this later work link him to the French Barbizon school. In this view of men laboring by the sea, gathering seaweed, the repose of late afternoon light on the water and headlands imbues the vast setting with an idyllic timelessness. The detailed rendering of the foreground rocks and vegetation quickly gives way to a broad generalizing of land, water, and atmosphere in the far distance. For McEntee, nature's specific facts and universal truths are integrally related to each other.

In George Smillie's *French Beach* of 1884 (p. 61), man and his labors are presented on a larger scale in relation to the pictorial space, a scale in which the magnitude of the sea is not overwhelming. In 1884–85 Smillie traveled to Europe and produced a series of works that in their painterliness, intimate scale, and quiet poetry suggest the influence of the French Barbizon school. *French Beach*, most likely an out-of-doors sketch, was painted at Etretat during this trip. In this work a man toils, folding nets by the sea, preparing for the next day's work. The sea is tranquil and poses no threat to his well-being or to his industry. In the prominent placement of the figure, boats, and nets on the foreground beach, Smillie indicates his genuine interest in the ordinary activities of people who lived and worked by the sea. This social concern links him to Barbizon artists, such as Jean-François Millet, and to Gustave Courbet.

A return to the sea for recreation and respite is a theme of several painters here; they moved the fête champêtre from the meadow or woods to the beach.

Thomas Hill, in *Picnic by the Sea* of 1873 (p. 62), presents an image of seaside play and relaxation. An established portraitist in San Francisco, Hill in 1866 traveled to Paris to study briefly with landscape painter Paul Meyerheim, who greatly encouraged his developing interest in landscape subjects. Hill returned to California in 1870, and from

then until his death in 1908, he frequently painted the magnificently dramatic California coast and the lofty peaks of the High Sierras.

In *Picnic by the Sea*, Hill depicts a pastoral outing that more frequently takes place, at least pictorially, in the shelter of a wooded glade. But here the picnickers perch atop a dramatic, exposed seaside bluff. The vulnerability of their position is assuaged by the sunny sky and quiescent sea. Winslow Homer employed a similar juxtaposition in *Long Branch, New Jersey* of 1869 (now in the collection of the Museum of Fine Arts, Boston) by placing at cliffside female figures that look like fragile porcelain dolls. Hill might have been familiar with this work, either through the original or through a related series of line engravings.

In *Sunset and Sea Fog*, c. 1910–15 (p. 63), Maurice Prendergast presents an image of play and relaxation; people sit, stroll, ride, sail, and romp at the meeting point of land and sea. In the 1890s, working in France with British artists who were attempting to come to terms with the innovations of French modernism and to assimilate its theories into their work, Prendergast executed numerous small oil sketches of women and children in festive environments—parks, boulevards, the shore. These subjects held his interest for the remainder of his career. On later trips abroad, from 1898 to 1910, Prendergast became enamored of the nondescriptive, abstract colorism of postimpressionists Paul Gauguin, Pierre Bonnard, and Edouard Vuillard, who chose colors for formal, aesthetic reasons, symbolic content, or pure visual impact, rather than any necessary correspondence to the hues of nature or the objects they depicted. Their work, along with the lyrical imagery of Puvis de Chavannes, had a lasting influence on Prendergast.

William J. Glackens also presents a joyful moment by the sea in *Beach Scene, New London* of 1918 (p. 64). Glackens traveled in 1895–96 to Bel-

gium, Holland, and France, where he first encountered the work of the French impressionists and postimpressionists. In the sunny *Beach Scene, New London*, Glackens's indebtedness to Pierre-Auguste Renoir is apparent in his feathery brushstroke and pastel palette. The sea poses little threat, offering instead a splendid opportunity for leisuretime frolic in high summer.

In William McGregor Paxton's *The Beach at Chatham* of c. 1915 (p. 65), men and women stroll, play, and swim, but it is the friendly expansiveness of sky and sea that is the artist's true interest. Paxton is better known for his carefully composed genre scenes of women in serene domestic environments. Among the more important influences on his artistic development were the light-suffused, intimate genre scenes of the seventeenth-century Dutch artist Jan Vermeer, and portraits by the seventeenth-century Spanish artist Diego Velázquez. *The Beach at Chatham* is a subject quite unusual for Paxton; however, his interest in light and atmosphere, and in the leisure activities of Boston's upper middle class, apparent in this work, is quite characteristic.

In Walt Kuhn's *Two Women Throwing Rocks by Seashore*, c. 1905–10 (p. 66), two women playfully toss pebbles at a bottle set upon a rock. Here again the sea is friendly and welcoming; it offers no threat or imposition. While studying in Germany and France from 1901 to 1903, Kuhn first saw the work of the French impressionists. Although the choppy, vivacious brushstroke Kuhn used to describe both land and sea tends to confound the distinctions between them, the prominent rocks in the foreground establish a safe sheltering space for the two figures. This painting is undated, but the short brushstrokes, outdoor subject, and colorism of *Two Women Throwing Rocks* suggest the work's date as well as Kuhn's indebtedness to impressionism.

At the turn of the century, many artists also perceived the seashore as a place for quiet repose and reverie. Numerous artists presented the human figure, often female, as an integral part of this natural place. In these idyllic representations, human space and sea space are harmoniously joined.

The American poet Hart Crane described an ideal harmony between the milky sea and the ivory bodies of two women in *The Bathers*, dated 1917.

Two ivory women by a milky sea; —
The dawn, a shell's pale lining restlessly
Shimmering over a black mountain-spear: —
A dreamer might see these, and wake to hear,
But there is no sound, — not even a bird-note;
Only simple ripples flaunt, and stroke, and float, —
Flat lily petals to the sea's white throat.

In *Arethusa* of 1897 (p. 67), Arthur B. Davies depicts the mythological nymph perched at cliff's edge in an idyllic setting. Davies is best known for his studies of nude female figures in sylvan environments. The quiet poetry, idealized subjects, and stylized human and natural forms of Puvis de Chavannes's work had a profound impact on the young Davies. *Arethusa* is typical of Davies's single-figure compositions; however, in this early work the female figure, turned away from the viewer, is more fully modeled than those in the artist's larger compositions.

Presented as a symbol of female purity in Ovid's *Metamorphoses*, Arethusa was chased by the river god Alpheus, in whose waters she had bathed. Just as he was about to overtake her, Artemis heard Arethusa's cries, swept her off to the island of Ortygia, and there turned her into a spring. Driven by love, Alpheus plunged into the earth and under the sea to form a stream that would mingle its waters with those swelling from Arethusa's spring.

Davies presents Arethusa safe upon the island of Ortygia. In her pure virginity she is sensuously

appealing yet unapproachable. The full modeling and the seaside setting suggest the influence of European academic painter Arnold Böcklin, whose retrospective exhibition Davies had seen in Hamburg, Germany, in 1897. Davies's soft, sensuous treatment of the flesh and painterly rendering of the landscape owe much to the influence of French impressionist Pierre-Auguste Renoir.

Rockwell Kent's *Pastoral* of 1914 (p. 68) portrays another idealized, seemingly mythic world, where land and sea are joined, and where the human realm and that of nature are fully integrated. Kent spent much of his life working near the sea—Monhegan Island, Maine (1906–07), Newfoundland (1913–15), and Alaska (1918). This work unites the human and natural spheres in a single vision, with a flowing, curvilinear rhythm in which the undulation of the land and the sea hardly differ. In his paradisaic image of a harmoniously integrated universe, Kent was influenced by the work of the postimpressionist Paul Gauguin as well as by the German expressionist Franz Marc.

In *Nude by the Sea* of c. 1904 (p. 69), Kenneth Hayes Miller presents, as does Davies, a female nude in a remote seaside setting. Miller's solidly modeled, clearly composed urban scenes and studies often depict women in domestic environments. (His work had a strong impact on the developing style of Reginald Marsh.) *Nude by the Sea*, in its almost tangible atmosphere and overall painterliness, is somewhat atypical; but its clear composition, full modeling, and focus on the idealized female nude is characteristic.

Augustus Vincent Tack creates a visual analogy between the billowing skirts of the figure standing high on the promontory and the wind-filled sails of the vessels in the harbor, as the nearest boat turns into the wind to tack, in *Seaside Scene*, c. 1895–1900 (p. 70). The silhouetting of this female figure lends the image universality, the figure representing all humanity in an ideal harmony with the sea. The loose, painterly handling and the outdoor subject suggest the date for this poetic scene.

The rippling, organic shapes of sea, sky, and land in George Grosz's *Resting* of c. 1940 (p. 71) seem to emanate from the figure of the female nude. This flowing visual energy integrally binds the compositional elements of the picture. Known for his biting visual satires of life in Weimar Germany, George Grosz moved to the United States in 1932 and continued to produce works critical of society's inequities. But in the dunes of Cape Cod he found a respite from life's harsh social realities. Grosz spent the summers of 1937 to 1942 and 1944 to 1945 on the Cape in Hyannis, Truro, and Wellfleet; *Resting* was most likely produced during one of these sojourns.

In the last quarter of the nineteenth century and the first half of the twentieth, artists and poets frequently described the variety of human activities by the sea. Some were recording the ways in which the greater number of middle-class Americans spent their leisure time; others expressed a compassion for the everyday routines of seaside laborers. Still others used the images metaphorically to suggest an idealized, harmonious relationship between the human and natural worlds. Their representations were diverse, but for all the artists considered here, the juxtaposition of mankind to the sea was of paramount importance.

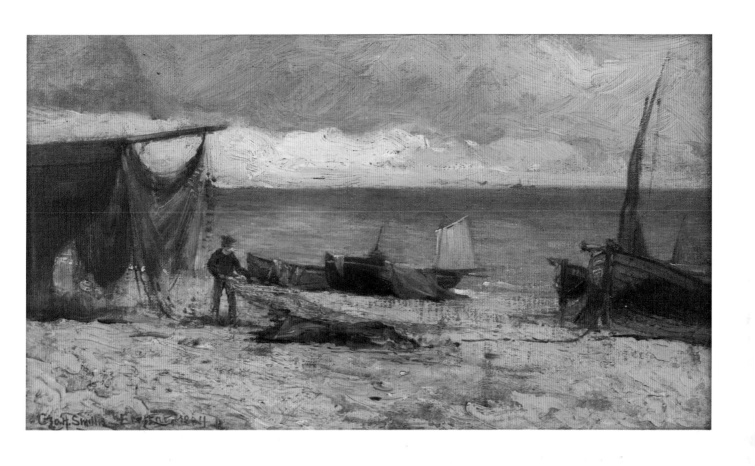

GEORGE SMILLIE (1840–1921)

French Beach, 1884

Oil on canvas, 9 × 16 in.
The Butler Institute of American Art,
Youngstown, Ohio

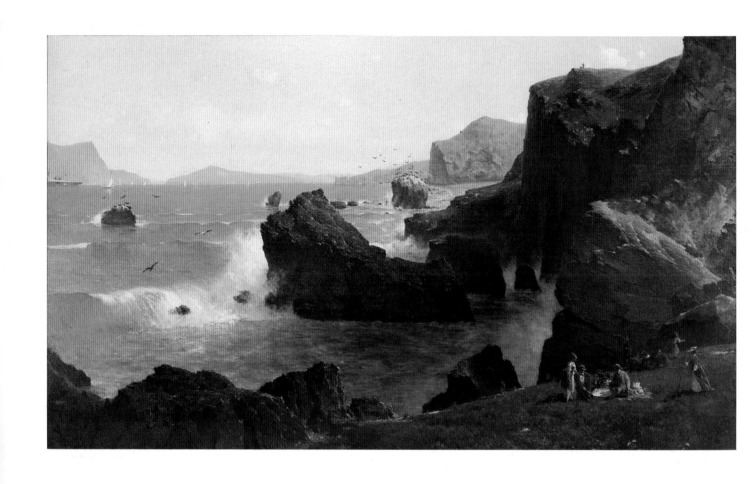

THOMAS HILL (1829–1908)

Picnic by the Sea, 1873

Oil on canvas, 51¼ × 87½ in.
D. Harold Byrd Collection, on extended loan to
The Butler Institute of American Art,
Youngtown, Ohio

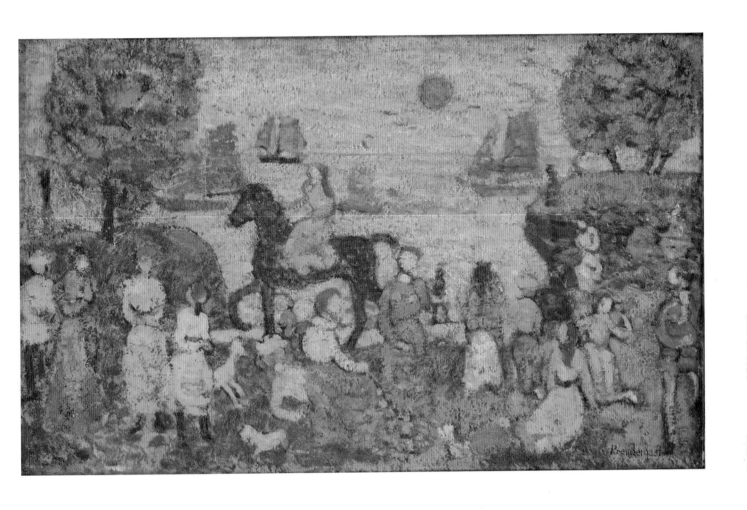

MAURICE PRENDERGAST (1859–1924)

Sunset and Sea Fog, c. 1910–15

Oil on canvas, 18 × 29 in.
The Butler Institute of American Art,
Youngstown, Ohio

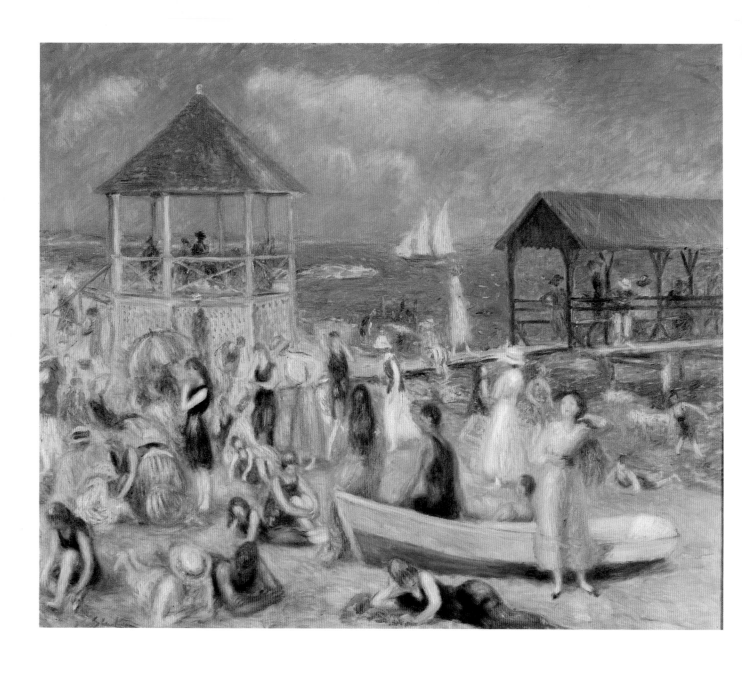

WILLIAM J. GLACKENS (1870–1938)

Beach Scene, New London, 1918

Oil on canvas, 26 × 31⅞ in.
Columbus Museum of Art, Columbus, Ohio;
Gift of Ferdinand Howald

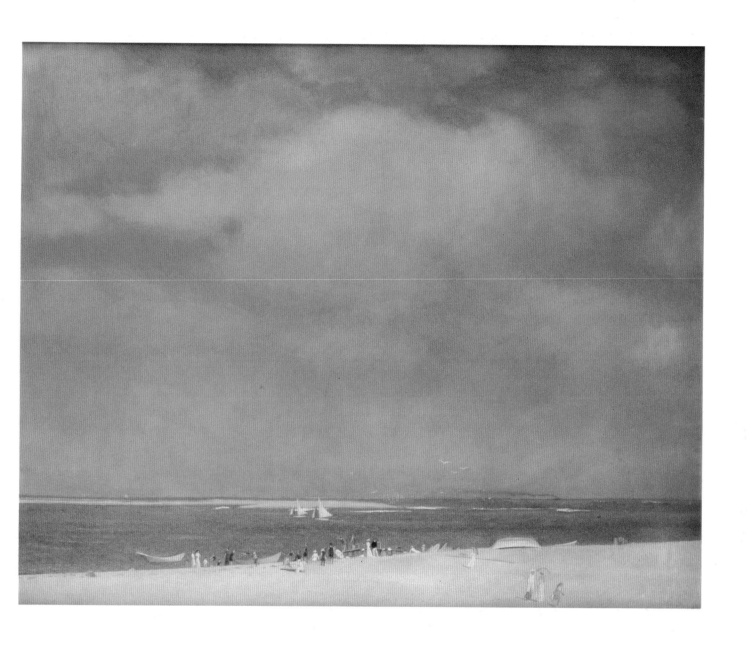

WILLIAM McGREGOR PAXTON (1869–1941)

The Beach at Chatham, c. 1915

Oil on canvas, 40 × 50 in.
The Butler Institute of American Art,
Youngstown, Ohio

WALT KUHN (1877–1949)

Two Women Throwing Rocks by Seashore, c. 1905–10

Oil on canvas, 20 × 24 in.
The Butler Institute of American Art,
Youngstown, Ohio

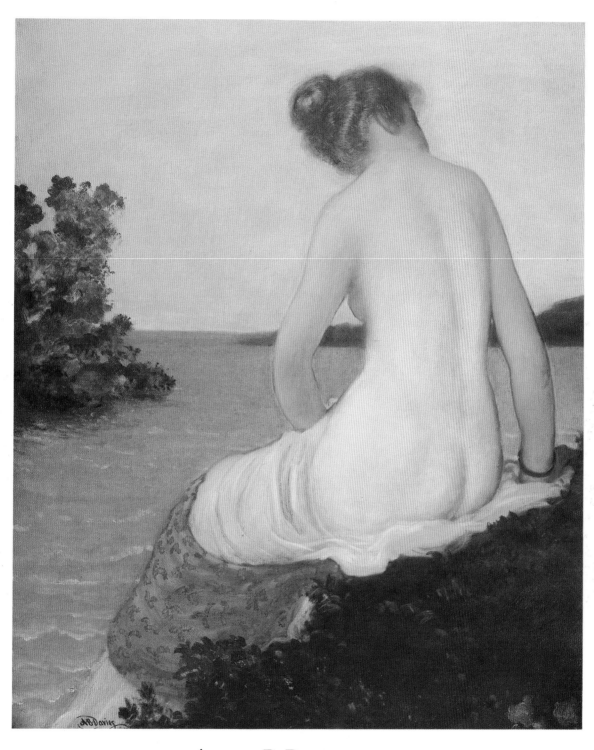

ARTHUR B. DAVIES (1862–1928)

Arethusa, 1897

Oil on canvas, 27 × 22 in.
The Butler Institute of American Art,
Youngstown, Ohio

ROCKWELL KENT (1882–1971)

Pastoral, 1914

Oil on canvas, 33⅛ × 44⅛ in.
Columbus Museum of Art, Columbus, Ohio;
Gift of Ferdinand Howald

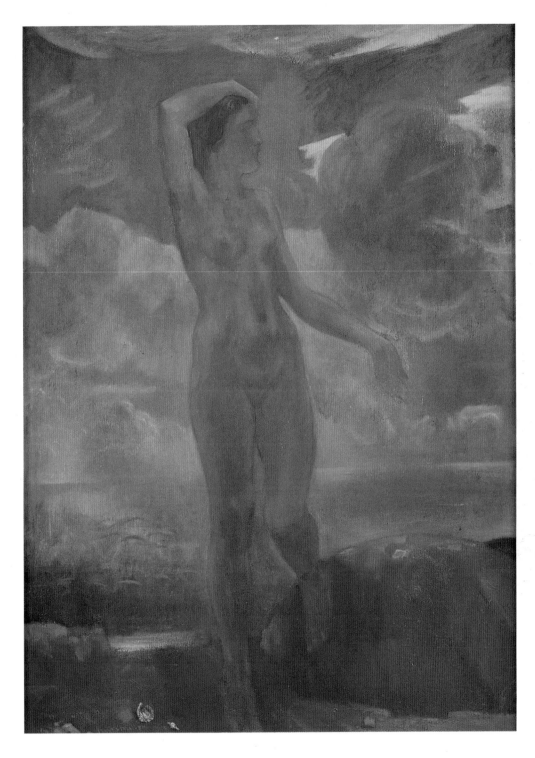

KENNETH HAYES MILLER (1876–1952)

Nude by the Sea, c. 1904

Oil on canvas, 25 × 18 in.
The Butler Institute of American Art,
Youngstown, Ohio

Augustus Vincent Tack (1870–1949)

Seaside Scene, c. 1895–1900

Oil on canvas, 24 × 18 in.
The Butler Institute of American Art,
Youngstown, Ohio

GEORGE GROSZ (1893–1959)

Resting, c. 1940

Oil on canvas, 20 × 26 in.
The Butler Institute of American Art,
Youngstown, Ohio

CHARLES GARABEDIAN (b. 1923)

Ulysses, 1984

Acrylic on canvas, 90 × 66 in.
The Eli Broad Family Foundation, Los Angeles

Modern Metaphors

Always the setting forth was the same,
Same sea, same dangers waiting for him
As though he had got nowhere but older.
Behind him on the receding shore
The identical reproaches, and somewhere
Out before him, the unravelling patience
He was wedded to. There were the islands
Each with its woman and twining welcome
To be navigated, and one to call "home."
The knowledge of all that he betrayed
Grew till it was the same whether he stayed
Or went. Therefore he went. And what wonder
If sometimes he could not remember
Which was the one who wished on his departure
Perils that he could never sail through,
And which, improbable, remote, and true,
Was the one he kept sailing home to?

—Odysseus
W. S. Merwin

For the majority of nineteenth-century artists, the physically descriptive component of a work of art, its correspondence to things seen in the real world, was of the greatest importance. During the twentieth century, however, abstraction has been the dominant form of artistic expression. As a subcurrent to this mainstream, numerous artists have continued to refer, directly or elliptically, to seascape imagery. Modernists Marsden Hartley and John Marin were virtually obsessed by the power and dynamic energy of the sea. Milton Avery found in sea imagery a visual mediator between pure abstraction and realism. Even such abstract artists as Adolph Gottlieb and Helen

Frankenthaler employed it to suggest psychic probing or as an analogy for the physical act of painting.

Twentieth-century seascapes are rarely straightforward depictions of a specific place. Rather, artists see in the varying moods and appearances of the ocean an external signifier for man's complex, ever-changing relationships to nature, to the universe, or to his own psychic mysteries.

The metaphorical allusions of twentieth-century poets are similarly diverse. In *Odysseus* (see epigraph), W. S. Merwin reinterprets Ulysses' attempts to regain his home; his journey, island to island over perilous seas, becomes a series of dal-

liances, a constant straying from a course or relationship growing ever more "improbable, remote, and true."

Using equally rich metaphors, twentieth-century artists have variously perceived and presented the sea as a source of spiritual nurture, as a locale where society is stripped to its ugliest core, as a world of fantasy where all is marvel and mystery, and as a fearsome power with the potential to consume and annihilate man and his constructs.

Marsden Hartley, one of the principal seascape artists of this century, frequently painted the sea in its varying moods, exploring the full spectrum of its spiritual and destructive manifestations, from pacific nurturer to violent destroyer. Hartley's earliest works were first shown in 1909 at Alfred Stieglitz's gallery "291," and their clearly discernible brushstrokes, heavy impasto, and vibrant color relate them to those of the French impressionists and postimpressionists. Through his association with Stieglitz and his circle, Hartley kept abreast of innovations in European art, particularly the work of Paul Cézanne, Henri Matisse, and Pablo Picasso. Hartley first traveled to Europe in 1912, visiting London, Paris, Munich, and Berlin. The work he produced between 1912 and 1915, characterized by increasing abstraction, vivid color, and symbolic reference, was strongly influenced by his investigation of Cézanne, analytical cubism, and the work of Franz Marc and Vassily Kandinsky.

On his return to New York in 1915, Hartley began to explore American subject matter through the landscape of Maine, New Mexico, and Gloucester. He spent the summer of 1916 in Provincetown, Massachusetts, where he produced a series of abstract, simple, planar geometric compositions based on the forms of sailing ships in the Provincetown harbor. The portrait of the sailing ship *Elsa* of 1916 (p. 82), in its frontality, balance, rectilinear order, and overall serenity, is typical of the work Hartley produced during a period of his life that he called "the Great Provincetown summer." These paintings are among the most abstract and peaceful works he ever made. In all the paintings in the series, the port is clearly presented as a safe retreat from the perils of the sea.

Eight Bells' Folly, Memorial to Hart Crane of 1933 (p. 83) presents a different side of the artist and a transformed relationship to the sea. Here Hartley depicts the sea as a malevolent destroyer. Its potential to obliterate man is manifest in the gaping jaws of the shark, whose curving form thrusts violently toward the foundering ship. In 1932, thanks to a Guggenheim fellowship, Hartley spent the year living and painting in Cuernavaca, Mexico. He was part of a small community of artists that included Paul Strand, Mark Tobey, Andrew Dasburg, and the poet Hart Crane, with whom Hartley established an especially close rapport. Hartley was stunned when Crane, returning to New York, committed suicide by leaping from the deck of a ship to the waters below. Hartley described the symbolism of his memorial tribute to Crane in a letter to a friend.

It has a very mad look as I wish it to have—there is a ship foundering—a sun, a moon, two triangular clouds—a bell with an '8' on it—symbolizing eight bells—or noon when he jumped off—and around the bell are lots of men's eyes—that look up from below to see who the new lodger is to be—on one cloud will be the number 33—Hart's age—and according to some occult beliefs is the dangerous age of a man—for if he survives 33—he lives on—Christ was supposed to be 33—on the other cloud will be 2—the sum of the poet's product.

Hartley portrayed the sea in a different guise in *Birds of the Bagaduce* of 1939 (p. 84), painting an ideal, benign image. Gulls soar skyward, echoing and reinforcing the sweeping patterns of the sailing

ships. In this windswept painting, man is in harmony with sea, sky, and land.

John Marin, another prolific twentieth-century seascape artist, spent most of his summers throughout his life along the rugged coast of Maine. During these summer excursions he executed watercolors portraying the vibrant energy of coastal waters. He presents an especially buoyant image of the sea in *Schooners, Maine* of 1928 (p. 85). The painting's overlapping planes of color, randomly zigzagging abstract lines, and angular massings of rock promote a sense of the power of the north Atlantic waters. Marin's interest in the underlying structure of forms was greatly influenced by the work of Paul Cézanne. Similarly his interest in expressing dynamic energy through color suggests an indebtedness to Henri Matisse and the Fauves.

The sunny, poetic work of Milton Avery forms a link between the American realists of the 1930s and the abstract expressionists of the 1940s and 1950s. A good friend to such abstract expressionists as Mark Rothko and Adolph Gottlieb, Avery chose an artistic course that fell somewhere between pure abstraction and representation. Largely self-taught, he is known for his planar, coloristic still lifes, landscapes, and genre scenes that celebrate the joys of life and the beauty of the world. The vivid colorism of Henri Matisse exerted the most profound influence on Avery's work of the 1930s and 1940s. A sense of delight, wit, and beauty flows through Avery's work and imbues it with an optimistic and celebratory character.

While visiting Laguna Beach in southern California during the summer of 1941, Avery sketched along the dramatic Pacific coast. Using these sketches as preliminary studies, Avery painted *Fantastic Rock, California* (p. 86) in his New York studio later that year. The work wittily contrasts the planar rendering of the lush aqua sea with a mock one-point perspective of the receding path and tall grass in the foreground. Similarly, he plays off the subtle modulations of color in the sea and sky against the vivacious patterns in the fantastic rock and in the flowers dotting the sides of the pathway. The lyrical scene Avery paints celebrates a joyous mingling of land and sea in an extraordinarily beautiful place.

Like Martin Johnson Heade, Jane Freilicher most often paints pastoral, seaside landscapes where the sea is a presence, but a distant one. Her work of the 1950s was influenced by the richly painted, intimate, and coloristic landscapes of Edouard Vuillard and Pierre Bonnard. In her sumptuously painted canvases, Freilicher often juxtaposes interior and exterior views—still life and landscape—to suggest the harmony of the human domain and nature. In *Marshes, Dunes, Fields* of 1977 (p. 87), the smooth visual transition from mown lawn to garden to dunes and sea suggests the easy flow from human space to natural space, or as Freilicher phrases it, "the simultaneous experience of an interior and an exterior world, closure and openness."

Throughout the twentieth century, formal compositional issues and the pure act of painting commanded artists' attention as subject matter—reference to things seen assumed a secondary role. A number of important American abstract painters, however, continued to refer indirectly and sometimes metaphorically in their works to aspects of the real world.

The allusions of twentieth-century poets express similar dualities. The journey Frank O'Hara describes in *To the Harbormaster* (whether to deity or lover is ambiguous) is sometimes on the sea or sometimes stops near the reeds of the marsh; the hazards and uncertainties of the journey allude to life, and his vessel becomes a symbol for the body and the self.

I wanted to be sure to reach you;
though my ship was on the way it got caught
in some moorings. I am always tying up
and then deciding to depart. In storms and
at sunset, with the metallic coils of the tide
around my fathomless arms, I am unable
to understand the forms of my vanity
or I am hard alee with my Polish rudder
in my hand and the sun sinking. To
you I offer my hull and the tattered cordage
of my will. The terrible channels where
the wind drives me against the brown lips
of the reeds are not all behind me. Yet
I trust the sanity of my vessel; and
if it sinks, it may well be in answer
to the reasoning of the eternal voices,
the waves which have kept me from reaching you.

Reference to the sea and to sea forms—shells, fish, and deep-water protozoan creatures—occurs frequently in the work of abstract expressionist Adolph Gottlieb. In his surrealist-influenced pictograms of the 1930s, he used underwater biomorphic and zoomorphic imagery to hint at the dark depths of the human psyche. The bipolar structure of Gottlieb's "Bursts" series of the 1950s—orblike form above and cacophonous massing of paint below—suggests an association and interrelatedness of the solar and the tidal. These paintings in their universal associations become abstract microcosms where an integral relationship exists between the celestial and the terrestrial. In *Spectre of the Sea* of 1947 (p. 88), the sea allusion refers outward to the depths of an aqueous world as well as inward to the recesses of psychic memory.

Helen Frankenthaler's work also alludes frequently to the sea and to ocean water. Her technique of pouring pools of watery acrylic paint onto unprimed canvas, then stopping or allowing the pigment to flow, alludes to the ebbings of ocean tides. In *Strength of the Sea* (p. 89), Frankenthaler established a rectilinear structure and then thwarted it by allowing a great swell of pigment to undermine its order and clarity, thus manipulating her materials to suggest the sea's power.

Many contemporary artists use nontraditional media in abstract compositions in ways that echo and reinforce the special content of their work. Michelle Stuart and Joe Zucker both utilize materials in this manner.

In *White…Moon Minister in the Marriage of Earth and Sea* of 1985 (p. 90), Michelle Stuart incorporates earth, stones, plants, pebbles, and shells in the encaustic surface of her work to refer to a physical coupling of elements. Stuart intends the abstract whiteness of the painting to conjure images of the fog along the rugged coast of the Pacific Northwest, where trees, rocks, sand, and water become one quiescent presence, part of a visually and spiritually unified whole. The monumental scale of the work draws the viewer into the world Stuart depicts, as sea space and human space become one.

Joe Zucker, on the other hand, presents the sea as a capricious force possessing the power to destroy in *5 + 7 Story Wok-Up Junk in a Maelstrom* of 1986 (p. 91). In the mid to late 1970s, he was part of a loosely defined group of New York artists referred to as "New Image" painters—artists to whom abstract, formalist concerns and reference to recognizable imagery were of equal importance. Riverboats, pirate ships, Spanish galleons, slave ships, and octopi and squid have appeared frequently in Zucker's work of the past decade.

5 + 7 Story Wok-Up Junk in a Maelstrom, a title jokingly referring to the artist's walk-up loft, presents the image of a ship buffeted by wind and sea, but the luminescent pigment and jaunty line counteract the ominous mood. Zucker has created a tongue-in-cheek synthesis of seeming opposites—the fearful and the funny, the weighty and

the insubstantial, east and west, land and sea, man and nature. The ropework grid structure is both subject (in its reference to the rigging of a ship) and material (in the support it lends to the pigment). Zucker eagerly promotes these paradoxical, multidimensional readings and likens the process to visions at sea, where at one moment the eye perceives a ship, the next moment an island mirage. While *5+7 Story Wok-Up Junk in a Maelstrom* does indeed present a fragile ship tossed about in a violent storm, it also shows a harmless pile of pigment and imagery—visual junk caught in the artist's net, his rope grid.

Judy Pfaff reverses the relationship between the artist's choice of materials and interest in subject matter by using funky, man-made materials to describe a natural underwater world of extraordinary beauty. Her *Untitled (Quartet for Quintana Roo)* of 1980 (p. 92) revels in the possibility of humankind's abandonment to the mysteries and visual marvels of an underwater world. Here the ocean offers the opportunity to depart terra firma, to discard the self and the confines of the ego, and to explore a new world of visual, tactile, and sensory experiences beneath the waves.

This work is one of four large collage studies Pfaff produced after a trip in 1980 to Mexico, where she first experienced the underwater world while snorkeling at Quintana Roo. Pfaff further developed the ideas and motifs explored in these collages in site-specific installations at the Contemporary Arts Center in Cincinnati and at the Holly Solomon Gallery in New York. Both the two- and three-dimensional works resound with the mysteries and vibrant energies of the deep-water domain.

Several contemporary artists, Cheryl Laemmle, Jody Pinto, David Wojnarowicz, Charles Garabedian, and Eric Fischl in particular, suggest a narrative element in their work that establishes a direct relationship between the human figure and the sea.

Cheryl Laemmle has used the figure of the monkey as a human signifier since 1978. In 1981 she began a series of paintings in which a lanky spider monkey is juxtaposed with other animals, objects, or humanoid forms. In many of these works the figure is placed on a ledge just within the edge of the canvas and thus seems to be neither part of the real world of the viewer nor of the pictorial world represented.

In *Monkey with Driftwood* of 1982 (p. 93), the monkey stares wistfully, perhaps mournfully, at the base of the driftwood. Behind them a tumultuous ocean sends frightening, raking waves across the canvas. In its despondency, the monkey seems to be remembering a time when, before it was devastated by the sea, the driftwood was a tree, and the monkey was free to swing skyward on its high branches. Framed on this ledge, the monkey can merely contemplate the devastation, a mute questioner of some distant sphinx. Yet the driftwood holds no answers to life's mysteries, only silence.

The narrative alluded to in Jody Pinto's *Henri: Three Times Over Himself* of 1983 (p. 94) represents the mingling of memory and desire. Pinto in 1983 produced a series of drawings depicting Henri La Mothe, a daredevil diver she had known when she was a child. In his drive, courage, and craziness, La Mothe became a hero to the artist—an alter ego, a symbol of fantasies realized. In the series, Pinto's physically demanding manipulation of traditional drawing materials—watercolor, gouache, grease crayon, and pencil—parallels her hero's grand, theatrical, daredevil exploits. Pinto abstracts, generalizes, and desexualizes the hero, turning him into a mythic Everyman. In some works, Henri is clearly diving, plummeting headfirst; in others he appears to fly in an effort to escape his watery fate below.

Henri: Three Times Over Himself can be read variously. As the title implies, Pinto is employing a

sequential, filmic visual device, simultaneously presenting three separate moments in the hero's fall. The silhouetted forms can also be read as two distinct figures, one desperately trying to prevent the other's fall. The ambiguous intent makes the fearsomeness of the image all the more compelling, as both figures will ultimately fall. Tongues, Pinto's symbol for sexual energy and the courage to speak, some sprouting hairs, bob about in the murky waters below. In their suggestion of both grasping lobster claws and gaping shark jaws, they reinforce the sea's fearsomeness. Henri's flight is a psychic journey, a courageous descent into the depths of the unconscious. For Pinto, the sea is unconsciousness itself, and humankind's ennobling heroism rests in the ability to courageously fathom the depths of that unknown realm.

In Charles Garabedian's *Ulysses* of 1984 (p. 72), the sea journeyer that the artist presents is not a specific individual whose extraordinary abilities allow him to navigate dangerous waters. Rather, he is Ulysses, the archetypal hero, vulnerable in his nakedness to the potentially destructive forces of the sea, but remote from quotidian reality. He is Garabedian's ideal of fortitude and fearlessness rather than the actual embodiment of those attributes, and in this idealization Garabedian exposes the vanity of man's efforts to subdue nature to his will. Ulysses represents a dream for Garabedian, a yearning for an ideal, but in the yearning is the admission of the dream's impossibility.

In David Wojnarowicz's diptych *The Untidiness of the Ocean* of 1982 (p. 95), images of a swimmer are painted over a world map, generalizing and universalizing his plight. The figure that struggles in one panel and drowns in the next is not an isolated individual but a symbol for all humanity. As the swimmer is overcome by water, green flying fish (green: the color of money, the military, and greed) soar triumphantly overhead. Thus, Wojna-

rowicz's diptych evolves into a metaphorical morality tale of human frustration and universal greed.

Eric Fischl frequently paints images that criticize the bourgeois hypocrisies of middle-class America, exposing its racism, greed, sexism, and lust for power. He often uses the sea as backdrop, presenting his morality tales on the decks of cabin cruisers or on the gritty sands of the beach. For Fischl, as man strips his body of clothing, so he strips away social constraints.

In *Digging Children* of 1982 (p. 96), Fischl exposes civilization's underbelly. While a black child darts off with a stolen radio, a white girl clutches ecstatically at a small black boy. At the same time, four naked white children anonymously, mysteriously, almost ritualistically dig in the sand; a hole dug to what unknown purpose—burial or torture of the black child? revenge for the stolen radio? pursuit of some elusive treasure? Fischl directly implicates himself and the viewer in the ambiguity of the scene—are the children digging? Or are they, with their breasts bare and their butts upturned, inviting the voyeur?

Robert Duncan's metaphor of alienation and waste in *Passage Over Water* is written from a similar socially engaged point of view.

We have gone out in boats upon the sea at night,
lost, and the vast waters close traps of fear about us.
The boats are driven apart, and we are alone at last
under the incalculable sky, listless, diseased with
* stars.*

Let the oars be idle, my love, and forget at this time
our love like a knife between us
defining the boundaries that we can never cross
nor destroy as we drift into the heart of our dream,
cutting the silence, slyly, the bitter rain in our
* mouths*
and the dark wound closed in behind us.

78

The theme of isolation in a diseased world is underscored by artist Luis Cruz Azaceta, who asserts social and moral issues in *104 Days Journey* of 1988 (p. 97). Azaceta's work often presents the struggle of the solitary individual against the repressive and dehumanizing social, political, and sexual forces of urban society. He has for the past five years explored apocalyptic imagery in his paintings of solitary figures or groups of figures in small vessels adrift upon turbulent waters. In *104 Days Journey* the apocalypse seems all the more imminent: a boat carrying a severed head tosses in a sea of numbers that refers to AIDS-related deaths. The work is both an indictment of those who have ignored this catastrophe and a call to political action.

While many artists suggest a narrative element in their works, others use seascape imagery purely metaphorically, with no suggestion of narrative relationships.

The beach scene David True presents in *Wind and Geometry* of 1978 (p. 98) is unpeopled and pristine. The long swells that end in spiky spears on the beach and the windswept palm exemplify the terrible force and power of nature. However, the brilliant light and extreme clarity of the composition imply that this power will not lay waste this vista; here, nature's power is awesome but benign. True painted *Wind and Geometry* while living near the beach in Savannah, Georgia, and the intense light along the Georgia coast shifted his palette toward almost garish hues. In this stylized image, the curvilinear rhythms of the waves are matched by the arching, windswept form of the tree to form a yin and yang cycle of earth and sea, the unity of opposites.

Richard Bosman is preoccupied by the power of nature to annihilate man and all his constructs. In *Vertical Boat* of 1980 (p. 99), the sea is presented as the destroyer. The violent energy of the waves threatens to overturn the small craft, hurling the solitary human figure, adrift without benefit of rudder or oars, to his death. A second foe, a human foe, lies well beyond the space depicted and is suggested only by the blood flowing from a wound on the figure's face.

Bosman derives the imagery for his heavily painted, expressionistic canvases from the mass media, television, or newspaper photography and from traditional and popular literature—Joseph Conrad, Herman Melville, and detective novels. In pitting the individual against the sea's caprice, Bosman creates a poignant metaphor for modern man's relationship to the universe. Implicit in his work is the assumption that man has as little control over his ultimate destiny as the figure without oars in the storm-tossed boat. When nature becomes violent, man is at her mercy.

As with Winslow Homer, William Trost Richards, Frederick Waugh, and many other late nineteenth-century seascape artists, Judy Rifka sets up a dramatic clash of primal forces on an epic scale in *Sea Wall* of 1983 (p. 100). Just as in the work of earlier artists, the violent meeting of water on rock plays itself out within the framework of the piece. The power of the sea dominates; man's efforts to hold back its fury with a sea wall of scattered sticks seem trifling and ineffectual. In Rifka's work, often produced from canvas, mesh, wood, and pigment, human figures or constructions are frequently swept away by forces well beyond their control. Sometimes these forces are political, sometimes natural and universal. In *Sea Wall*, the ocean is the dominant force that holds the earth, humanity, and all human constructs in thrall.

Mark Tansey's *Coastline Measure* of 1987 (p. 101) depicts a land survey team's vain attempt to scientifically and logically measure the immeasurable—the coast, the ever-changing meeting point of water and rock. As waves crash about them, em-

phasizing the violent potential of nature, land surveyors stretch puny lines across the rocks, feebly struggling to impose order upon chaos. The ocean seems almost to mock man's efforts to impose a Euclidean geometry upon its limitless expanse. For Tansey, it underscores the futility of attempting to understand and articulate the full nature of visual experience. Well-versed in the history of art, Tansey frequently uses visual quotes to create a link with the historical past and to rethink the underlying significance of past events and images in modern terms.

In *Water Drawings* of 1988 (p. 102), Wade Saunders has assembled a cluster of underwater debris, some of it sumptuously vegetal and provocatively erotic and some industrially manufactured—discarded fragments of a civilization gone down with the ship. However, at the same time that they appear to be fragments of sunken debris, these bronze forms are vessels, containers for water, conveyers of hope and life. Such things might wash ashore on the beach, the wrack of the sea. They might be found in a shipwreck, artifacts of marine archaeology. Or one might find such things floating on the water—fragments of shells and seed clusters from exotic underwater flora.

The title of Michael McMillen's sculptural ship-portrait *Pequod II* of 1987 (p. 103) evokes the ship that quested after the elusive white whale in Herman Melville's *Moby-Dick*, but the tired, rusty old bark McMillen presents is dramatically different from its namesake. Through this heap of recycled debris McMillen seems to be articulating man's desire for perfection and for control of the quixotic forces of nature. But *Pequod II*, a rag-tag construction propelled only by worn-out Electrolux vacuum cleaners and torn sails, suggests the utter futility of man's pursuit of the elusive ideal.

Tom Otterness presents an unusually buoyant seascape image in *Boat with Wave* of 1986 (p. 104).

Although the vessel is perched precariously on the crest of the wave, the two figures in the boat seem oblivious to any threat of harm. Otterness comically reverses typical male and female roles: as the nude woman prepares to plunge her spear aggressively forward, the man leans back, holding on to his fishing pole for dear life. Throughout his work, Otterness creates microcosms—small worlds in which tiny, plump humanoids work, play, struggle, and copulate. Some of these worlds are idealized and yearned for; others are fearsome and dreaded. Still others are governed by the loves, lusts, and labors of ordinary men and women. In every instance, these small worlds stand as metaphorical signifiers for the world as we know it, as we wish it were, or as we fear it might become.

In *Yellow Ocean* of 1984 (p. 105), Jedd Garet has painted a purely fictional seascape. The red sky, turquoise blue rock, and yellow sand would find no precedents in the natural world. Little concerned with recording the specific details of things seen, Garet uses strident color and opposing forms to suggest the clashing elemental forces of nature—the opposition of earth, water, and air. In this inharmonious universe where contradiction and discord predominate, man's private uncertainties are echoed and reinforced by the maelstrom around him. Garet often presents wasp-waisted, androgynous human figures in confining architectural and natural environments. His figures are heavily painted, generalized, and abstract, often truncated or presented with severed limbs. When Garet uses natural forms, they are fragmented and torn from context. Frequent classical allusions, disquieting relationships between figure and environment, and surreal, dreamlike references disclose Garet's indebtedness to the metaphysical, poetic paintings of Italian artist Giorgio de Chirico.

Most of the twentieth-century artists and writers considered here have been more interested in the symbolic possibilities than in the literal description of seascape imagery. Although the metaphors vary considerably, from visions of an idealized, harmonious universe to horrific images of imminent destruction, suggestions of a world out of balance and out of control abound. Manifestations of this feeling emerge in our alienation from ourselves and from our natural environment, profoundly felt throughout the twentieth century. The occurrence of two major world wars and many smaller ones, the development of nuclear weapons affording us the opportunity to destroy not only human society but the entire world, and the spread of AIDS, a fatal and seemingly uncontrollable disease now afflicting thousands, have all contributed to this sense of universal disorder. Perhaps the greatest fear is that we have done just enough to bring about the ultimate destruction of our world, upsetting beyond recall the delicate balance that once existed between us and our environment.

The seascape metaphor differs from other contemporary apocalyptic imagery in that the instruments of final doom are natural events rather than human actions. But the cause of destruction is the lack of balance in our relationship to nature. Much of the work explored here has to do with this central issue. The works by Pfaff, Avery, and Freilicher all celebrate a magnificent moment when an intimacy between man and nature existed. But Garabedian, Laemmle, and McMillen all lament the loss of that rapport, and Hartley, Azaceta, and Garet show the world gone awry as a result of that disharmony.

Also central to the seascape metaphor is our fear of losing control of our lives and, by extension, of the world. Although images of final destruction are rare (few artists choose to portray the final cataclysmic tidal wave), images of man adrift in a storm-tossed boat are frequent, the craft lacking either oars or rudder—those symbolic implements by which one might guide his course or control his fate. The fears that this unsteered state evoke are profound and universal.

Thus in the approximately 150 years surveyed here, the seascape image has been extended by artists to its polar extremes of meaning—from one in which man is master of his universe to one in which he is adrift in a sea of uncertainty, unable to guide his course. While some artists find freedom in this abandonment of ego, this loosening of will, others experience only existential dread. Throughout this century, the metaphorical implications of seascape imagery along this spectrum of meaning are rich and diverse.

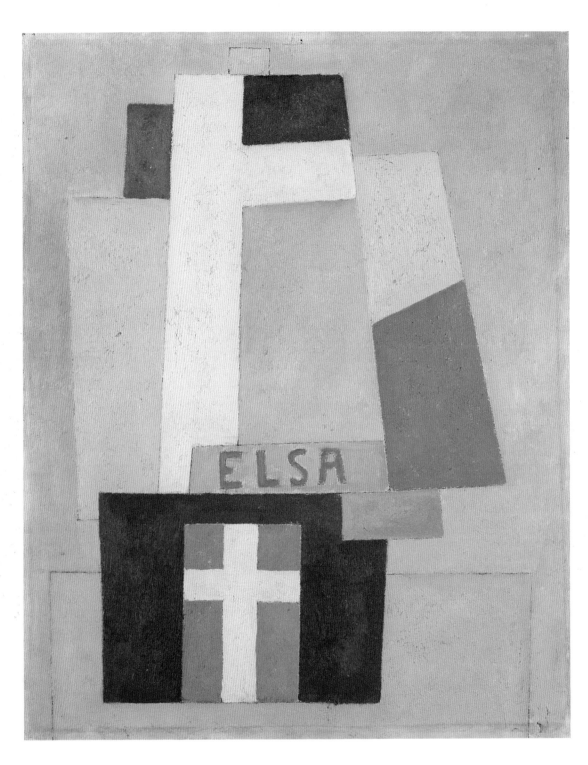

Marsden Hartley (1877–1943)

Elsa, 1916

Oil on composition board, 20 × 16 in.
University Art Museum, University of Minnesota, Minneapolis;
Bequest of Hudson Walker from the Ione and Hudson Walker Collection

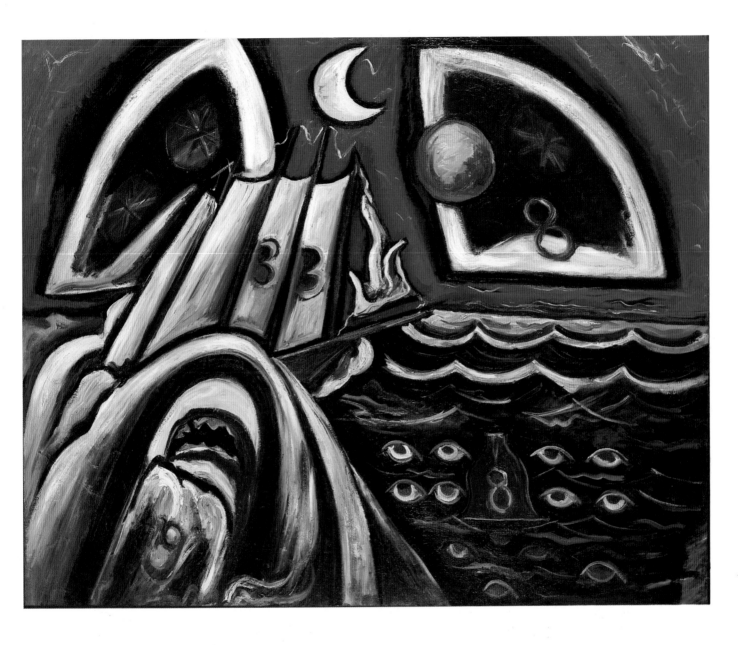

MARSDEN HARTLEY (1877–1943)

Eight Bells' Folly, Memorial to Hart Crane, 1933

Oil on canvas, 31⅝ × 39½ in.
University Art Museum, University of Minnesota, Minneapolis;
Gift of Ione and Hudson Walker

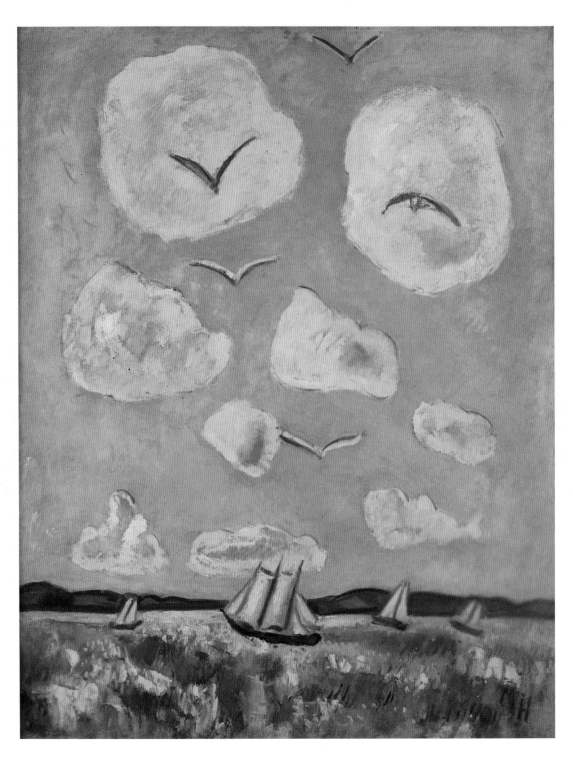

MARSDEN HARTLEY (1877–1943)

Birds of the Bagaduce, 1939

Oil on canvas, 28 × 22 in.
The Butler Institute of American Art,
Youngstown, Ohio

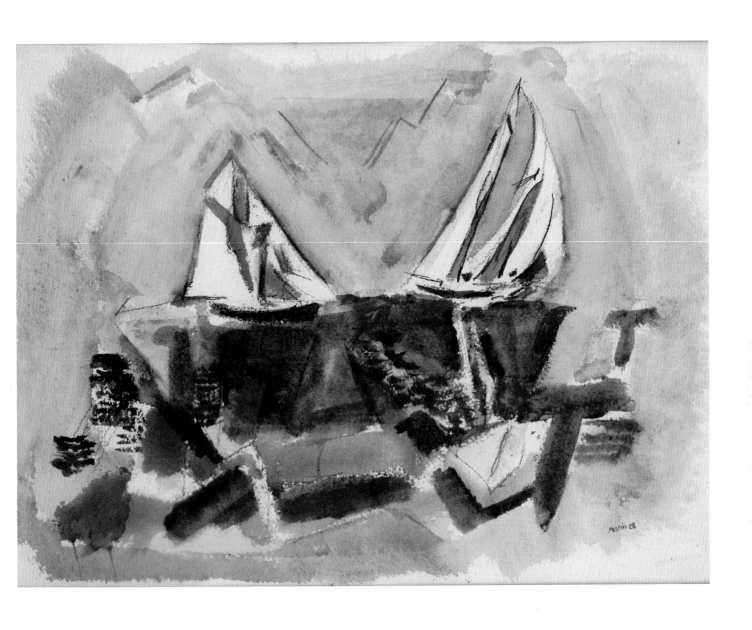

JOHN MARIN (1870–1953)

Schooners, Maine, 1928

Watercolor on paper, 16 × 22 in.
The Butler Institute of American Art,
Youngstown, Ohio

MILTON AVERY (1885–1965)

Fantastic Rock, California, 1941

Oil on canvas, 28 × 36 in.
University Art Museum, University of Minnesota, Minneapolis;
Gift of Mr. and Mrs. Roy R. Neuberger

JANE FREILICHER (b. 1924)

Marshes, Dunes, Fields, 1977

Oil on canvas, 70½ × 72⅝ in.
The Herbert W. Plimpton Collection,
on extended loan to Rose Art Museum,
Brandeis University, Waltham, Massachusetts

87

ADOLPH GOTTLIEB (1903–1974)

Spectre of the Sea, 1947

Oil on canvas, 30 × 38 in.
The Montclair Art Museum,
Montclair, New Jersey

HELEN FRANKENTHALER (b. 1928)

Strength of the Sea, 1987

Acrylic on canvas, 107 × 68 in.
Collection Beverly and Chester Firestein, Beverly Hills, California

MICHELLE STUART

White…Moon Minister in the Marriage of Earth and Sea, 1985

Earth, stones, shells, plants, and encaustic, 99 × 198 in.
Max Protetch Gallery, New York

JOE ZUCKER (b. 1941)

5 + 7 Story Wok-Up Junk in a Maelstrom, 1986

Acrylic, sash cord, and wood, 102½ × 102½ in.
Lent by the artist, courtesy of Hirschl and Adler Modern, New York

Judy Pfaff (b. 1946)

Untitled (Quartet for Quintana Roo), 1980

Mixed media, contact paper, mylar on tracing/graph paper, 31¼ × 80⅞ in.
Collection The Rothschild Bank AG, Zurich,
Courtesy La Jolla Museum of Contemporary Art, La Jolla, California

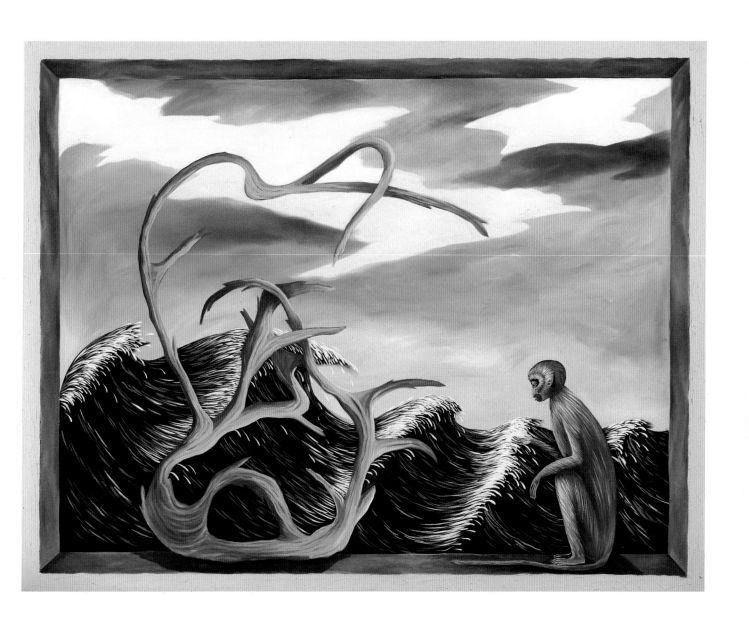

CHERYL LAEMMLE (b. 1947)

Monkey with Driftwood, 1982

Oil on canvas, 56½ × 72 in.
Mr. and Mrs. Frederick R. Mayer, Denver

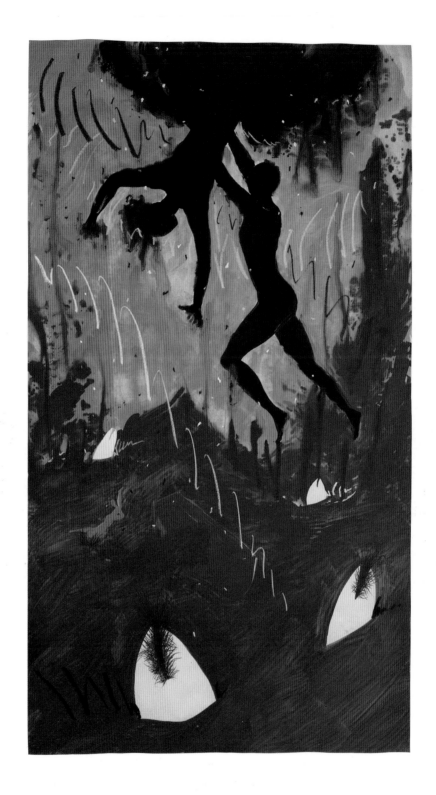

JODY PINTO (b. 1942)

Henri: Three Times Over Himself, 1983

Gouache, grease crayon, and watercolor on paper, 108 × 60 in.
Lent by the artist, courtesy of Hal Bromm Gallery, New York

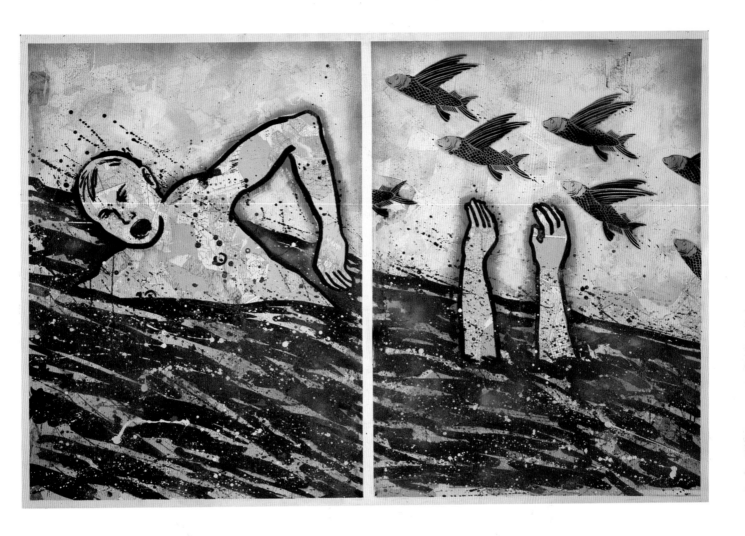

Davíd Wojnarowicz (b. 1954)

The Untidiness of the Ocean, 1982

Map, spray paint on masonite, 48 × 72 in.
Emily and Jerry Spiegel Collection

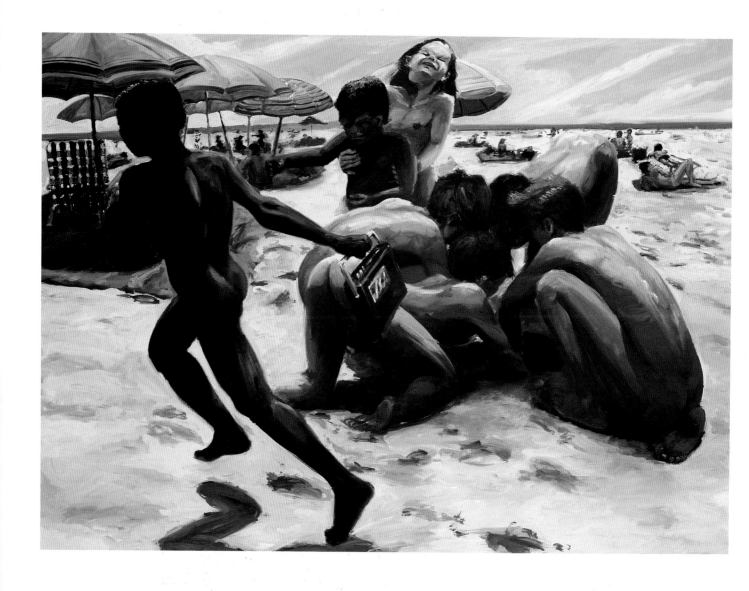

ERIC FISCHL (b. 1948)

Digging Children, 1982

Oil on canvas, 66 × 92 in.
The Rivendell Collection, New York

Luis Cruz Azaceta (b. 1942)

104 Days Journey, 1988

Acrylic on canvas, 64 × 42 in.
Lent by the artist, courtesy of Frumkin/Adams Gallery, New York

DAVID TRUE (b. 1942)

Wind and Geometry, 1978

Oil on canvas, 60 × 84 in.
Collection The Rothschild Bank AG, Zurich,
Courtesy La Jolla Museum of Contemporary Art, La Jolla, California

RICHARD BOSMAN (b. 1944)

Vertical Boat, 1980

Oil on canvas, 91⅝/₁₆ × 44⅞ in.
Brooke and Carolyn Alexander, New York

JUDY RIFKA (b. 1945)

Sea Wall, 1983

Oil and mesh on linen and wood, 62 × 106½ in.
Brooke Alexander Gallery, New York

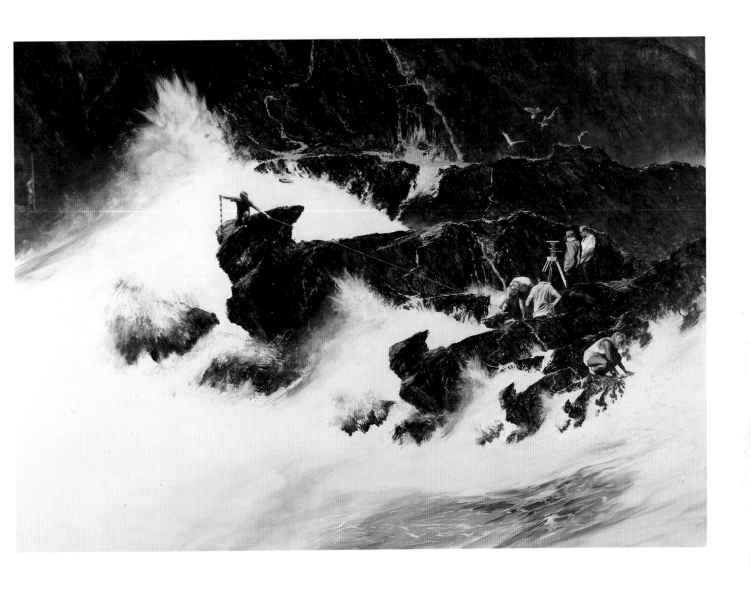

MARK TANSEY (b. 1949)

Coastline Measure, 1987

Oil on canvas, 87 × 122 in.
Edward R. Downe, Jr., New York

W ADE S AUNDERS (b. 1949)

Water Drawings, 1988

Bronze, 20 unique casts
Diane Brown Gallery, New York

MICHAEL McMILLEN (b. 1946)

Pequod II, 1987

Mixed-media construction, 96 × 206 × 77 in.
Lent by the artist, courtesy of Patricia Hamilton Gallery, New York

TOM OTTERNESS (b. 1952)

Boat with Wave, 1986

Bronze, 11 × 15 × 9 in.
Brooke Alexander Gallery, New York

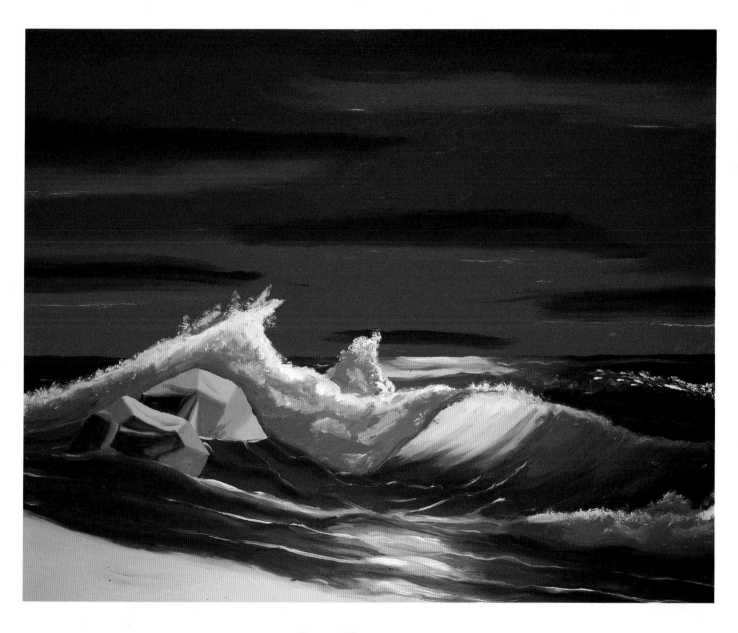

JEDD GARET (b. 1955)

Yellow Ocean, 1984

Acrylic on canvas, 84 × 105 in.
The Eli Broad Family Foundation, Los Angeles

Artists' Biographies

Italicized page numbers refer to illustrations.

IVAN ALBRIGHT (1897–1983) *40*
Born in Illinois. He first studied painting with his father, Adam Emory Albright, who had been a student of Thomas Eakins. In 1916 he studied architecture at the University of Illinois and in 1918–19 served as an army medical draftsman in France. On his discharge Albright worked as a medical illustrator in Oak Park, Illinois, and from 1920–23 he studied at the School of the Art Institute of Chicago. In the fall of 1923 Albright studied briefly at the Pennsylvania Academy of the Fine Arts, and in 1924 he studied with Charles Hawthorne at the National Academy of Design.

MILTON AVERY (1885–1965) *86*
Born in Altmar, New York, and raised in Hartford, Connecticut, where his family moved in 1905. Largely self-taught, Avery studied briefly in 1923 with Charles Noel Flagg at the Connecticut League of Art Students. When he moved to New York in 1925, Avery enrolled in evening classes at the Art Students League with Kenneth Hayes Miller and Yasuo Kuniyoshi. Avery's sophisticated use of color and formally simple compositions suggest the influence of Henri Matisse.

LUIS CRUZ AZACETA (b. 1942) *97*
Born in Cuba, Azaceta studied at the School of Visual Arts in New York.

GEORGE BELLOWS (1882–1925) *36*
Born in Columbus, Ohio. From 1904–06 Bellows studied at the New York School of Art with Robert Henri, who encouraged his interest in social realism. Bellows is best known for his depictions of dynamic athletic activity (boxing, swimming, etc.) and vivid urban scenes.

THOMAS BIRCH (1779–1851) *42*
Born in England, Birch moved to the United States in 1794 with his father, an engraver and enamel painter. As an assistant in his father's workshop in Philadelphia, Birch was exposed to the marine painting traditions embodied in the work of seventeenth-century Dutch artists and of the eighteenth-century French artist Claude Joseph Vernet. Birch became the leading marine painter of his era.

RICHARD BOSMAN (b. 1944) *99*
Son of a captain in the merchant marine, Bosman was born in Madras, India. He studied at the Byam Shaw School of Painting and Drawing in London from 1964–69 and with Alex Katz and Philip Guston at the New York Studio School from 1969–71.

WILLIAM BRADFORD (1823–1892) *32*
Born in Fairhaven, Massachusetts. Bradford began painting ship portraits and harbor views in the mid-1850s. During the 1860s he frequently accompanied exploratory expeditions to Labrador and the Arctic, which he documented in sketches and photographs. These preliminary studies were the basis for the dramatic polar scenes that established his reputation.

ALFRED THOMPSON BRICHER (1837–1908) *31*
Born in Portsmouth, New Hampshire. Bricher began painting in Boston in 1851; he moved to New York in 1870. Best known for his coastal views of New England, he traveled frequently on sketching trips along the coast of Maine, Massachusetts, and Rhode Island.

HARRISON BROWN (1831–1915) *49*
Born in Maine. Brown spent much of his life painting that state's rugged, rocky coast. He frequently painted the shores of Casco Bay near Portland.

MATHER BROWN (1761–1831) *8*
Born in Boston, Brown studied briefly with Gilbert Stuart before leaving the United States for England in 1780. He studied with Benjamin West in 1781, and beginning in 1782 he regularly exhibited his idealized portraits and history paintings at the British Royal Academy.

JAMES E. BUTTERSWORTH (1817–1894) *17*
Born on the Isle of Wight, England. Buttersworth received his early training from his father, the British marine painter Thomas Buttersworth. He moved to the United States about 1845 and settled in West Hoboken, New Jersey. He was the leading ship portraitist of his day.

EMIL CARLSEN (1853–1932) *54*
Born in Copenhagen. Trained as an architect, Carlsen moved to the United States in 1872. He was a studio assistant in Chicago to the Danish-born marine painter Lauritz Bernhard Holst. He is best known for his Chardinesque still lifes.

THOMAS CHAMBERS (1815–1866) *15*
Born in England, Chambers had moved to the United States by the mid-1830s. With no formal training he began painting river views, landscapes, and seascapes in the 1830s. He is best known for his depictions of naval battles that often derived from popular print sources.

ARTHUR B. DAVIES (1862–1928) *67*
Born in Utica, New York. Davies studied in 1878 at the Chicago Academy of Design with J. Roy Robertson and later in 1883 at the School of the Art Institute of Chicago with Charles Corwin. In 1885–86 he moved to New York to study at the Art Students League with Kenyon Cox. In 1888 Davies visited the Puvis de Chavannes exhibition at the National Academy of Design, which had a profound impact on his work. In 1908 he exhibited with The Eight, and he was instrumental in organizing the 1913 Armory Show.

STUART DAVIS (1894–1964) *37*
Born in Philadelphia and raised in East Orange, New Jersey, Davis first studied painting with Robert Henri in New York from 1909–12. Henri greatly encouraged Davis's independent creativity and his interest in urban subject matter. Davis exhibited five watercolors in the 1913 Armory Show, where he first encountered the works of Picasso. He was also influenced by the nondescriptive colorism in the works of Henri Matisse, Paul Gauguin, and Vincent van Gogh.

ERIC FISCHL (b. 1948) *96*
Born in New York, Fischl trained at Arizona State University and at California Institute of the Arts, where he received his B.F.A. in 1972.

HELEN FRANKENTHALER (b. 1928) *89*
Born in New York, Frankenthaler studied in high school with Rufino Tamayo and at Bennington College with Paul Feeley. She also studied briefly with Hans Hofmann. Influenced by Jackson Pollock's gestural abstract expressionism, Frankenthaler began in the early 1950s to work directly on

unprimed canvas, pouring thin washes of pigment directly onto the canvas.

JANE FREILICHER (b. 1924) *87*
Born in Brooklyn. Freilicher received her B.A. (1947) from Brooklyn College and in 1947 attended the Hans Hofmann School of Fine Arts both in New York and in Provincetown. She received her M.A. (1948) from Columbia University.

CHARLES GARABEDIAN (b. 1923) *72*
Born in Detroit. Garabedian studied painting and art history at the University of California, Los Angeles, from 1957–61.

JEDD GARET (b. 1955) *105*
Born in Los Angeles and trained at the Rhode Island School of Design in Providence.

ROBERT SWAIN GIFFORD (1840–1905) *48*
Born near New Bedford, Massachusetts. He studied painting with Albert Van Beest, a Dutch-American painter of marine views, and later with William Bradford. In 1864 Gifford opened a studio in Boston and two years later moved to New York. He became an associate of the National Academy of Design in 1867 and a full academician in 1878.

WILLIAM J. GLACKENS (1870–1938) *64*
Born in Philadelphia, Glackens worked in 1892 as a reporter-illustrator for the Philadelphia *Press* along with George Luks, Everett Shinn, and John Sloan. He studied briefly at the Pennsylvania Academy of the Fine Arts. He was a member of The Eight, and in 1913 he was instrumental in the organization of the pioneering Armory Show.

ADOLPH GOTTLIEB (1903–1974) *88*
Born in New York, Gottlieb studied in 1920–21 at the Art Students League, with John Sloan and Robert Henri, and in Paris at the Académie de la Grande Chaumière. He was one of the major figures of the abstract expressionist movement, and his work of the 1940s and 1950s reflected his interest in primitive iconography and color relationships.

GEORGE GROSZ (1893–1959) *71*
Best known for his biting visual satires of life in Weimar Germany, Grosz moved to the United States in 1932 to escape Nazi persecution and to teach at the Art Students League. He stayed in the United States for the remainder of his life, becoming an American citizen in 1938.

JAMES HAMILTON (1819–1878) *20*
Born in Ireland, Hamilton moved with his family to Philadelphia in 1834. He studied at a drawing school and at the Pennsylvania Academy of the Fine Arts. Known as the "American Turner," he painted romantic marine and landscape scenes with dramatic lighting.

MARSDEN HARTLEY (1877–1943) *82–84*
Born in Lewiston, Maine. Hartley studied art in Cleveland from 1896–98 with John Sermon and with Cullen Yates, a local impressionist-influenced painter. In 1899 he moved to New York to study at the New York School of Art with William Merritt Chase. From 1900–04 Hartley studied at the National Academy of Design and began a lifetime habit of spending the summer months painting in Maine, where he settled permanently in 1934.

MARTIN JOHNSON HEADE (1819–1904) *34*
Born in Lumberville, Pennsylvania, Heade received early artistic training in portraiture from Edward Hicks and his cousin Thomas Hicks. From about 1840–43, he traveled abroad, and in 1859 he established a studio in New York at the Tenth Street Studio Building, where he met Frederic Church. Using New York and Boston intermittently as his home base, Heade traveled frequently from 1863 on to Florida and to South America, where he executed the gorgeous small paintings of lush tropical blossoms and birds for which he is so well known. He was one of the principal figures of the Luminist movement.

ROBERT HENRI (1865–1929) *35*
Born in Cincinnati. Henri studied at the Pennsylvania Academy of the Fine Arts under Thomas Anshutz from 1886–88 and at the Académie Julian and the Ecole des Beaux-Arts in Paris in 1891. From 1891–94 he taught at the Pennsylvania Academy, where he gathered around him a group of talented young artist-illustrators, including William J. Glackens, George Luks, Everett Shinn, and John Sloan. This group would become the nucleus of The Eight. Henri moved in 1904 to New York, where he continued to teach. His belief that art grew from life and his respect for the dignity of everyday activities inspired the subject matter of a generation of artists.

THOMAS HILL (1829–1908) *62*
Born in Birmingham, England, Hill moved with his family to the United States in 1844. In 1853 he studied at the Pennsylvania Academy of the Fine Arts under Peter Frederick Rothermel, a prominent portraitist and painter of historical subjects. In 1861 Hill moved to San Francisco and established himself as a portraitist and a landscape painter of western scenes.

WINSLOW HOMER (1836–1910) *52, 53*
Born in Boston, Homer was an apprentice in the Boston lithographic firm of J. H. Bufford from 1855–57, and from 1857–75 he worked as a freelance illustrator. During the Civil War, Homer served as an artist-correspondent for *Harper's Weekly*. He visited Europe for the first time in 1866, sharing a studio in Paris with American artist Albert W. Kelsey. His *Prisoners from the Front* was included in the 1866 Exposition Universelle, where Homer most likely first saw the work of French realists Gustave Courbet and Edouard Manet. Homer returned to the United States in 1867, and in 1872 he took a studio at the Tenth Street Studio Building in New York. In 1881–82, Homer lived near Tynemouth on the coast of England. He settled permanently in Prout's Neck, Maine, in 1884.

ANTONIO JACOBSEN (1850–1921) *18, 19*
Born in Copenhagen, Jacobsen moved to the United States in 1873, settling first in New York, then moving in 1881 to West Hoboken, New Jersey. Jacobsen is considered the foremost ship portraitist of the late nineteenth century.

WILLIAM SMITH JEWETT (1812–1873) *16*
Born in South Dover, New York. Jewett moved in 1838 to New York City, where he studied at the National Academy of Design. He became an associate of the Academy in 1845. Like Antonio Jacobsen, Jewett is best known for his detailed portraits of ships.

JOHN FREDERICK KENSETT (1816–1872) *33*
Born in Cheshire, Connecticut. Kensett received early training in draftsmanship and engraving in his father's engraving and publishing firm in New Haven. He exhibited his first landscape painting at the National Academy of Design in New York in 1838, and in 1840 he began a seven-year period of travel and study in Europe. In 1848 he was elected an associate of the National Academy of Design and in 1849 became an academician. Best known for his poetic landscapes, Kensett was an important figure in the American Luminist movement.

ROCKWELL KENT (1882–1971) *68*
Born in Tarrytown Heights, New York. From 1900–02 Kent studied art and architecture at Columbia University and was a pupil of William Merritt Chase and Robert Henri. Kent is best known for his generalized, abstracted landscapes and his heroic depictions of the everyday lives of working people.

WALT KUHN (1877–1949) *66*
Born in Brooklyn. From 1899–1900 Kuhn lived in San Francisco and worked as a cartoonist for *The Wasp*. From 1901–03 he studied in Paris at the Académie Colarossi and in Munich at the Academy of Fine Arts with the animal painter Heinrich von Zugel. Along with Arthur B. Davies, he was instrumental in organizing the Armory Show of 1913. He is best known for his portraits of solitary circus performers.

CHERYL LAEMMLE (b. 1947) *93*
Born in Minneapolis, Minnesota. Laemmle attended Humboldt State University in Arcata, California, where she received her B.A. in 1974, and Washington State University in Pullman, where she was awarded her M.A. in 1978.

FITZ HUGH LANE (1804–1865) *21*
Born in Gloucester, Massachusetts. Lane began his artistic career as an apprentice in Pendleton's lithography firm in Boston, where he learned perspective and the importance of accurate detail. Lane painted ship portraits, harbor views, and landscapes from about 1840 on. He is considered a major figure in the American Luminist movement.

JERVIS MCENTEE (1828–1891) *56*
Born in Rondout, New York. McEntee studied painting briefly with Frederic Church from 1850–51. In 1858 McEntee moved to New York and took a studio in the Tenth Street Studio Building along with John Casilear, Sanford R. Gifford, John F. Kensett, and William Hart. In 1868 he traveled to England, France, and Italy, and in 1869 he rented a studio in Rome in the same building as Frederic Church and William S. Haseltine. McEntee's poetic landscapes are associated with the Hudson River and Barbizon schools.

MICHAEL MCMILLEN (b. 1946) *103*
Born in Los Angeles. He received his B.A. from San Fernando Valley State College, and his M.A. and M.F.A. from the University of California, Los Angeles. He trained in the art of model making as a film studio technician in Hollywood. He has worked on such films as *Close Encounters of the Third Kind* and *Blade Runner*.

JOHN MARIN (1870–1953) *85*
Born in Rutherford, New Jersey. Marin studied painting at the Pennsylvania Academy of the Fine Arts under Thomas Anschutz and Hugh Breckenridge from 1899–1903. He

studied in 1904 at the Art Students League in New York and in 1905 moved to Paris. He exhibited there at the Salon d'Automne between 1907–09 and at the Salon des Indépendants in 1907. Marin frequently depicted the rugged Maine coast in his watercolors and oils.

REGINALD MARSH (1898–1954) *38, 39*
Born in Paris, Marsh was raised in Nutley, New Jersey. He attended Yale University from 1916–20. On graduating he moved to New York and became a freelance illustrator. He was on the staff of the *New York Daily News* from 1922–25, and throughout the 1920s he executed illustrations of city subjects for such periodicals as *The New Yorker, Esquire, Fortune,* and *Life.* He began studies in painting in 1922 at the Art Students League with Kenneth Hayes Miller, George Bridgman, and George Luks. Considered a second-generation Ashcan school artist, Marsh is best known for his numerous studies of the urban scene.

KENNETH HAYES MILLER (1876–1952) *69*
Born in Oneida, New York. Miller studied at the Art Students League in 1892 with H. Siddons Mowbray, Kenyon Cox, and J. Carroll Beckwith and, about 1894, with William Merritt Chase. Miller taught at the New York School of Art from 1900–11 and at the Art Students League, with only two brief interruptions, from 1911–51. Miller is best known for his classically composed figure studies and genre scenes.

EDWARD MORAN (1829–1901) *29*
Older brother of the well-known landscape painter Thomas Moran, Edward was born in England. The family moved to the United States in 1844 and settled in Philadelphia, where Moran studied with the marine painter James Hamilton and German-born landscape painter Paul Weber. Moran is best known for his panoramic marine paintings.

TOM OTTERNESS (b. 1952) *104*
Born in Wichita, Kansas, Otterness studied at the Art Students League in New York in 1970 and in the Independent Study Program at the Whitney Museum of American Art in 1973.

WILLIAM MCGREGOR PAXTON (1869–1941) *65*
Born in Baltimore. Paxton received a scholarship to attend the Cowles Art School in Boston in 1887 and studied there with Dennis Miller Bunker until 1889. After studying in Paris at the Ecole des Beaux-Arts with Jean-Léon Gérôme, he returned to Boston to resume his studies at the Cowles School, this time with Joseph De Camp. Best known for his depictions of the lives of the upper-middle class, Paxton painted many portraits of fashionable Bostonians and Philadelphians, genre scenes, and murals.

JUDY PFAFF (b. 1946) *92*
Born in London. She received her B.F.A. from Washington University in St. Louis in 1971 and her M.F.A. in 1973 from Yale University.

JODY PINTO (b. 1942) *94*
Born in New York. Pinto studied at the Pennsylvania Academy of the Fine Arts from 1964–68 and was awarded her B.F.A. from the Philadelphia College of Art in 1973.

FAIRFIELD PORTER (1907–1975) *41*
Born in Winnetka, Illinois. He attended Harvard University from 1924–28 and later studied painting with Thomas

Hart Benton and Boardman Robinson at the Art Students League from 1928–30. Porter lived in Italy from 1930–32, and in 1935 he settled in Croton-on-Hudson, New York, working in a studio off Union Square in New York City. In 1949 Porter moved to Southampton, Long Island. There and in Great Spruce Head Island, Maine, he painted the majority of works for which he is best known today.

MAURICE PRENDERGAST (1859–1924) *63*
Born in St. John's, Newfoundland, Prendergast moved with his family to Boston in 1861. Little is known about his early training, but by 1883 he was supporting himself as an illustrator. In 1886 he and his brother Charles first traveled to France. From 1891–c. 1895, once again in France, Prendergast studied with Gustave Courtois at the Académie Colarossi and later with Jean Joseph Benjamin-Constant, Joseph Blanc, and Jean Paul Laurens at the Académie Julian. An early modernist, Prendergast frequently painted idyllic scenes in which color and form expressed the uncomplicated pleasures of the shore and the city.

WILLIAM TROST RICHARDS (1833–1905) *50, 51*
Born in Philadelphia, Richards began his artistic studies in that city in 1850 with Paul Weber, a German-born portrait and landscape painter. Influenced by the romantic/realist vision of the Hudson River school, Richards is best known for his seascapes depicting the coasts of New England and Cornwall.

JUDY RIFKA (b. 1945) *100*
Born in New York, Rifka studied at Hunter College, the New York Studio School, and at the Skowhegan School of Painting and Sculpture.

ROBERT SALMON (1775–c. 1845) *22*
Born in England. Salmon was trained in the seventeenth-century Dutch marine tradition with its emphasis on compositional order and formal structure. He painted ship portraits and harbor views in Liverpool and in Greenock, Scotland, before moving to the United States in 1828. He settled in Boston and painted numerous panoramic scenes of Boston harbor and other neighboring ports. He exerted considerable influence on Fitz Hugh Lane, Martin Johnson Heade, William Bradford, and numerous other nineteenth-century American seascape artists.

WADE SAUNDERS (b. 1949) *102*
Born in Berkeley, California. Saunders received his B.A. from Wesleyan University in 1971 and his M.F.A. from the University of California, San Diego, in 1974.

FRANCIS A. SILVA (1835–1886) *30*
Born in New York. With little formal training, he first exhibited his work at the National Academy of Design in 1868. He continued to exhibit there for the next twenty years. He was elected to the American Watercolor Society in 1872. Although he occasionally painted landscape and genre images, Silva is best known for his harbor views.

GEORGE SMILLIE (1840–1921) *61*
Born in New York. Smillie received his first training in draftsmanship from his father, the painter James Smillie. In 1861 he studied with James Hart, in 1862 he exhibited his first work at the National Academy of Design, and in 1864 he was elected an associate of the Academy. Smillie frequently sketched during the summer months in the Adirondacks and the Catskills, and in 1871 he traveled west to sketch in the Rockies and at Yosemite.

RUSSELL SMITH (1812–1896) *47*
Born in Glasgow, Scotland. He came to the United States in 1819 and settled in Philadelphia, where he studied painting with James R. Lambdin. From 1834–40 he worked as a scene painter for several theaters in Philadelphia.

MICHELLE STUART (b. 1938) *90*
Born in Los Angeles. Stuart studied at the Chouinard Institute in Los Angeles from 1954–55, at the Instituto de Bellas Artes in Mexico City with Diego Rivera from 1955–56, and at the New School for Social Research in New York from 1958–60.

AUGUSTUS VINCENT TACK (1870–1949) *70*
Born in Pittsburgh and raised in New York, Tack is best known for a stunning group of poetic abstractions now at the Phillips Collection in Washington, D.C. He studied in New York about 1889–90 with John La Farge and in the early 1890s with H. Siddons Mowbray and John Twachtman. In 1893 he traveled to France, where he studied with Oliver Merson and visited impressionist Claude Monet in his studio at Giverny. During his long career Tack painted academic portraits, murals, and evocative, highly coloristic abstract studies.

MARK TANSEY (b. 1949) *101*
Born in San Jose, California. Tansey studied painting at Hunter College in New York from 1975–78.

DAVID TRUE (b. 1942) *98*
Born in Marietta, Ohio, True received both his B.F.A. (1966) and his M.F.A. (1967) from Ohio University in Athens.

FREDERICK J. WAUGH (1861–1940) *55*
Born in Bordentown, New Jersey. Waugh studied at the Pennsylvania Academy of the Fine Arts with Thomas Eakins and Thomas Anshutz from 1880–83. In 1883 he studied briefly at the Académie Julian with Adolphe-William Bouguereau and Tony Robert-Fleury. Through the 1880s Waugh painted portraits, genre scenes, and landscapes. In 1893, while visiting England, he first began to paint seascapes, a genre that held his interest throughout the remainder of his career.

DAVID WOJNAROWICZ (b. 1954) *95*
Born in New Jersey, Wojnarowicz moved to New York in the mid-1970s. Largely self-taught, he had his first solo show in 1982.

JOE ZUCKER (b. 1941) *91*
Born in Chicago. Received his B.F.A. (1964) and his M.F.A. (1966) from the School of the Art Institute of Chicago. He moved to New York in 1968.

Bibliography

Baur, John I. H. "Francis A. Silva: Beyond Luminism." *The Magazine Antiques* 118 (November 1980): 1018–31.

————. *George Grosz*. New York: Whitney Museum of American Art and MacMillan, 1954.

Beam, Philip C. *Winslow Homer at Prout's Neck*. Boston: Little, Brown, 1966.

Belz, Carl. "Charles Garabedian: Twenty Years of Work." *Arts Magazine* 57 (May 1983): 104–10.

Bermingham, Peter. *American Art in the Barbizon Mood*. Washington, D.C.: National Collection of Fine Arts, 1975.

Brown, Jeffrey R., and Ellen W. Lee. *Alfred Thompson Bricher: 1837–1908*. Indianapolis: Indianapolis Museum of Art, 1973.

Brown, Milton. *American Painting from the Armory Show to the Depression*. Princeton: Princeton University Press, 1955.

Burke, Doreen Bolger, et al. *American Paintings in the Metropolitan Museum of Art 3*. New York: Metropolitan Museum of Art and Princeton University Press, 1980.

The Butler Institute of American Art. *Selections from the Permanent Collection*. Youngstown, Ohio, 1979.

————. *Sixty Years of Collecting American Art: An Index to the Permanent Collection*. Youngstown, Ohio, 1979.

Cooper, Helen A. *Winslow Homer Watercolors*. Washington, D.C.: National Gallery of Art and Yale University Press, 1986.

Cummings, Paul. "Interview: Jody Pinto Talks with Paul Cummings." *Drawings* 9, no. 1 (May–June 1987): 10–14.

Curry, Larry. *John Marin, 1870–1953*. Los Angeles: Los Angeles County Museum of Art, 1970.

Doty, Robert, ed. *Jane Freilicher Paintings*. Manchester, N.H.: The Currier Gallery of Art; New York: Taplinger, 1986.

Driscoll, John Paul, and John K. Howat. *John Frederick Kensett: An American Master*. Worcester, Mass.: Worcester Art Museum; New York: Norton, 1985.

Ferber, Linda S. *William Trost Richards*. Brooklyn: The Brooklyn Museum, 1973.

Ferguson, Bruce W., ed. *Eric Fischl Paintings*. Saskatoon, Saskatchewan: Mendel Art Gallery, 1985.

Fox, Howard N. *Avant-Garde in the Eighties*. Los Angeles: Los Angeles County Museum of Art, 1987.

Fox, Howard N., et al. *Content: A Contemporary Focus 1974–1984*. Washington, D.C.: Hirshhorn Museum and Sculpture Garden, Smithsonian Institution, 1984.

Gerdts, William H. *American Impressionism*. New York: Abbeville, 1984.

Goodrich, Lloyd. *Reginald Marsh*. New York: Abrams, 1972.

Green, Eleanor. *Maurice Prendergast: Art of Impulse and Color*. College Park, Md.: University of Maryland Art Gallery, 1977.

Gumpert, Lynn, and Ned Rifkin. *New Work New York*. New York: New Museum, 1982.

Haskell, Barbara. *Marsden Hartley*. New York: Whitney Museum of American Art and New York University Press, 1980.

————. *Milton Avery*. New York: Whitney Museum of American Art and Harper and Row, 1982.

Hayt-Atkins, Elizabeth, and Susan Kandel. "Mark Tansey." *Art News* 87 (January 1988): 152.

Hendricks, Gordon. *The Life and Work of Winslow Homer*. New York: Abrams, 1979.

Hess, Hans. *George Grosz*. London: Studio Vista, 1974.

Homer, William I. *Robert Henri and His Circle*. Ithaca: Cornell University Press, 1969.

————. *Alfred Stieglitz and the American Avant Garde*. Boston: New York Graphic Society, 1977.

Howat, John K. *John Frederick Kensett, 1816–1872*. New York: American Federation of Arts, 1968.

Howat, John K., et al. *American Paradise: The World of the Hudson River School*. New York: Metropolitan Museum of Art; dist. by Abrams, 1987.

Howe, Octavius T., and Frederick C. Matthews. *American Clipper Ships*. New York: Dover Publications, 1986.

Johnson, Ken. "Foursquare and Square-Rigged: New Coordinates in the Imagery of Joe Zucker's Art." *Arts Magazine* 61 (Summer 1987): 25–27.

Kardon, Janet. *The East Village Scene*. Philadelphia: Institute of Contemporary Art, University of Pennsylvania, 1984.

Kertess, Klaus. *Marin in Oil*. Southampton, N.Y.: Parrish Art Museum, 1987.

Komac, Dennis L. *Wade Saunders: Selected Sculpture 1974–1984*. San Diego: University Art Gallery, San Diego State University, 1985.

Kuspit, Donald. *Fischl*. New York: Vintage Books, 1987.

Lane, John R. *Stuart Davis: Art and Art Theory*. Brooklyn: Brooklyn Museum, 1978.

Larson, Susan C. *Michael C. McMillen: The New World*. New York: Patricia Hamilton, 1986.

Leval, Susana Torruella. *Luis Cruz Azaceta: Tough Ride Around the City*. New York: Museum of Contemporary Hispanic Art, 1986.

Lewis, Beth Irwin. *George Grosz: Art and Politics in the Weimar Republic*. Madison: University of Wisconsin Press, 1971.

Liebmann, Lisa. *Joe Zucker*. New York: Hirschl and Adler Modern, 1987.

McClintic, Miranda. *Directions 1981*. Washington, D.C.: Hirshhorn Museum and Sculpture Garden, Smithsonian Institution, 1981.

McCormick, Carlo. *David Wojnarowicz: Paintings and Sculpture*. Philadelphia: Institute of Contemporary Art, University of Pennsylvania, 1985.

McShine, Kynaston. *The Natural Paradise: Painting in America*. New York: Museum of Modern Art, 1976.

Mandel, Patricia C. F. "Selection VII: American Paintings from the Museum's Collection, c. 1800–1930." *Bulletin of Rhode Island School of Design: Museum Notes* 63 (April 1977).

Marshall, Richard. *New Image Painting*. New York: Whitney Museum of American Art, 1979.

Martin, Richard. " 'Rust Is What Our Metal Substitutes for Tears' The New Paintings of Mark Tansey." *Arts Magazine* 60 (April 1986): 18–19.

_____. "Cezanne's Doubt and Mark Tansey's Certainty on Considering Mont Sainte-Victoire." *Arts Magazine* 62 (November 1987): 79–83.

Marx, Leo. *The Machine in the Garden: Technology and the Pastoral Ideal in America*. London, Oxford, and New York: Oxford University Press, 1964.

Masheck, Joseph. *Judy Rifka*. Charlotte, N.C.: Knight Gallery, Spirit Square Arts Center, 1984.

Morgan, Stuart. *Wade Saunders: Water Drawings*. New York: Diane Brown Gallery, 1988.

Morrin, Peter, et al. *The Advent of Modernism: Post-Impressionism and North American Art, 1900–1918*. Atlanta: High Museum of Art, 1986.

North, Percy, et al. *American Paintings and Sculpture in the University Art Museum Collection*. Minneapolis: University Art Museum, University of Minnesota, 1986.

Novak, Barbara. *Nature and Culture: American Landscape Painting 1825–1875*. New York: Oxford University Press, 1980.

Nygren, Edward J. *Views and Visions: American Landscape Before 1830*. Washington, D.C.: Corcoran Gallery of Art, 1986.

Oliphant, Bryan, and Glenn C. Peck. *Important Marine Paintings*. New York: H. V. Allison Galleries and Oliphant and Company, 1986.

Pincus-Witten, Robert. *Jedd Garet*. Pasadena, Calif.: Twelvetree Press, 1984.

Rose, Barbara. *Frankenthaler*. New York: Abrams, 1970.

Rose, Matthew. "David Wojnarowicz: An Interview." *Arts Magazine* 62, no. 9 (May 1988): 60–65.

Schneede, Uwe M., et al. *George Grosz: His Life and Work*. New York: Universe Books, 1979.

Schwartz, Sanford. "Joe Zucker's New Work." *Artforum* 25 (Summer 1987): 107–109.

Shearer, Linda. *Projects: Tom Otterness*. New York: Museum of Modern Art, 1987.

Silk, Gerald. *Jody Pinto: The Henri Drawings*. Philadelphia: Institute of Contemporary Art, University of Pennsylvania, 1984.

Spassky, Natalie, et al. *American Paintings in the Metropolitan Museum of Art* 2. New York: Metropolitan Museum of Art and Princeton University Press, 1985.

Stebbins, Theodore E. *The Life and Works of Martin Johnson Heade*. New Haven: Yale University Press, 1975.

Stein, Roger B. *Seascape and the American Imagination*. New York: Whitney Museum of American Art, 1975.

Tuchman, Phyllis. *Michael C. McMillen: Hermetic Landscapes*. New York: Patricia Hamilton, 1988.

Tucker, Marcia. *American Paintings in the Ferdinand Howald Collection*. Columbus, Ohio: Columbus Gallery of Fine Arts, 1969.

Varjabedian, Hrag. *Garabedian: Painter of the Uprooted*. Allentown, Penn.: Center for the Arts, Muhlenberg College, 1987.

Wilkin, Karen. *Stuart Davis*. New York: Abbeville, 1987.

Wilmerding, John. *Winslow Homer*. New York: Praeger, 1972.

_____. *American Marine Painting*. New York: Abrams, 1987.

Wilmerding, John, et al. *American Light: The Luminist Movement 1850–1875*. Washington, D.C.: National Gallery of Art, 1980.

_____. *Paintings by Fitz Hugh Lane*. Washington, D.C.: National Gallery of Art; New York: Abrams, 1988.

Zimmer, William. *Richard Bosman*. New York: Brooke Alexander, 1987.